Myerstown and Eastern Lebanon County

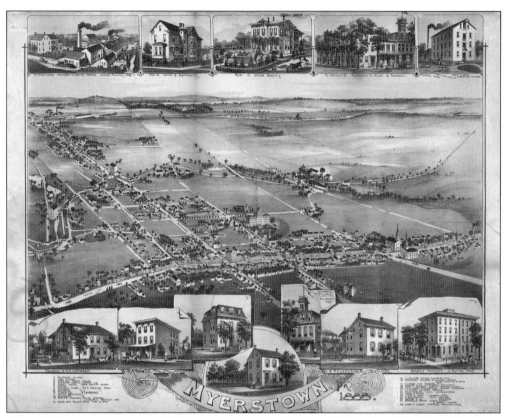

This 1889 panoramic map of Myerstown was drawn and published by Thaddeus Mortimer Fowler of Morrisville, Pennsylvania. From 1889 to 1902, Fowler is known to have had a particularly extensive and productive association with another panoramic artist and publisher, James B. Moyer of Myerstown, Pennsylvania. Most likely, they met in Myerstown in 1889. (Courtesy of Institute of American Deltiology.)

ON THE FRONT COVER: A group of Myerstown citizens posed on Main Street, at the eastern end of the streetcar line, in 1907. Further information about this postcard is found on page 9. (Courtesy of Institute of American Deltiology.)

ON THE BACK COVER: Schaefferstown's lower fountain and water trough on South Market Street seems to have been the center of attraction for Fetter family children and Harry Umberger and James Keath on a day in 1911. Or, might the attraction have been the horse? (Courtesy of Gerald A. Collins.)

POSTCARD HISTORY SERIES

Myerstown and Eastern Lebanon County

Donald R. Brown

ARCADIA
PUBLISHING

Published by Arcadia Publishing
Charleston, South Carolina

Printed in the United States of America

Library of Congress Control Number: 2012944908

For all general information contact Arcadia Publishing at:
Telephone 843-853-2070
Fax 843-853-0044
E-mail sales@arcadiapublishing.com
For customer service and orders:
Toll-Free 1-888-313-2665

Visit us on the Internet at www.arcadiapublishing.com

*This book is dedicated to the hardy pioneers from the Germanic
states who settled eastern Lebanon County from the Schoharie Valley
of New York State in the 1720s and to those who arrived through
the Port of Philadelphia during the succeeding colonial decades.*

CONTENTS

ACKNOWLEDGMENTS

My role in compiling this book is due initially to a referral from Linda Manwiller, director of the Myerstown Community Library. The use of postcards and other historical information in the collections of the Myerstown library is acknowledged. Archivist Brian Kistler, vice president Donald L. Rhoads Jr., and board member Art Claggett—all of the Lebanon County Historical Society—were most cooperative for my research needs.

Sincere thanks are due to the following Lebanon County postcard collectors and friends who eagerly and willingly loaned cards from their collections: Gerald A. Collins, Nancy Gambler, Nancy Kohl Gettle, Jack L. Kiscadden Jr., Carroll D. Lape, Leonard H. Schott, Terry O. Schott, Cecilia Fetter Stephan, Michael A. Trump, and Joel J. Wiest. Credit is provided for every card borrowed. Images not credited are from the Institute of American Deltiology in Myerstown, Pennsylvania.

Thanks also are due to Shirley A. Weinhold for supplying Richland verifications; to Joseph Horning, for sharing information about an early Amish settlement in Jackson Township; to Ernest A. Krall and Steve Keller for Buffalo Springs information; and to Alice Oskum of Historic Schaefferstown, Inc., for help when requested. Charles H. Huber's bicentennial history of Schaefferstown, *Schaefferstown, Pennsylvania, 1763–1963*, and the Myerstown Bicentennial Committee's book, edited by Viola Kohl Mohn, *Myerstown, Pennsylvania, 1768–1968*, were useful printed sources to flesh out captions in this book.

Thanks are due also to John C. Fralish Jr. and Anthony L. Iezzi, volunteers at the Institute of American Deltiology, who clarified electronic requirements necessary for me to function knowledgeably with Arcadia's acquisitions editor Abby Henry, who was ever helpful in answering my frequent inquiries.

My greatest debt of gratitude goes to Ryan R. Patches, of Myerstown, for scanning all of the postcards included in this publication as well as for his related volunteer work at the Institute of American Deltiology, in Myerstown, Pennsylvania.

INTRODUCTION

Eastern Lebanon County is located in the Lebanon Valley of Pennsylvania, one of the most fertile agricultural valleys in the United States. Anchored by Reading to the east and Harrisburg to the west, the Lebanon Valley is a 50-mile segment of the Great Valley of the East that extends from the Delaware Water Gap on the Pennsylvania–New Jersey border, southwestward 500 miles to the Cumberland Gap on the Virginia-Kentucky-Tennessee border. The Great Valley is the initial Appalachian valley to be traversed as one travels westward from the Piedmont; thus, the Lebanon Valley served to some extent as a conduit on the Appalachian frontier, the first American West.

Most of the earliest Europeans to enter the Lebanon Valley were immigrants from the Germanic states and from the north of Ireland and Scotland. The latter, the Scots-Irish, were generally more restless, more curious about what lay beyond those Blue Mountains to the north and west than the Germanic peoples, who realized they had found their "Promised Land" when they saw the limestone-rich soil on the bed of the Lebanon Valley and the clear streams. Having suffered religious wars, harsh winters, and poverty in the lands along the lower Rhine for generations, they were only too glad to settle down and become tillers of the soil and create fruitful farmsteads and prosperous villages in the bowl of the Lebanon Valley. This area would, in 1813, become eastern Lebanon County, Pennsylvania.

Today, eastern Lebanon County encompasses five municipalities, but in 1813, there was only one—Heidelberg Township. Jackson Township was established as a separate entity from Heidelberg in 1820, and the same occurred with Millcreek Township in 1844. Richland Borough was incorporated in 1906, and Myerstown Borough was incorporated in 1912. Prior to February 16, 1813, all of this territory had been part of Dauphin County, but this would be the case for only 28 years. Previous to 1785, this land had been part of original Lancaster County since its formation in 1729. Before that time, eastern Lebanon County would have been part of one of William Penn's three original counties of 1682, Chester (the others being Bucks and Philadelphia).

This book's concentration on Myerstown is due to several factors: the large number of available photographic postcards of the town; its importance as a commercial center among the eastern Lebanon County towns by the first half of the 20th century; and its status as the hometown of the author.

Myerstown had been named Tulpehockentown by Isaac Meier, who laid out lots on his plantation along the Tulpehocken Creek in 1768. Of necessity, a loose commercial neighborhood had existed by that time. *Tulpehocken* was the name given to it by Native Americans, particularly

the Lenni-Lenapi', or Delaware. Tulpehocken translates as "Land of the Turtles." Bog turtles in particular were plentiful in the area until the late 20th century. However, Myerstown was not the only important early commercial center in eastern Lebanon County. Schaefferstown, in Heidelberg Township, six miles south of Myerstown, was equally if not more important as a center of commerce in late colonial times and in the early republic. There, two key colonial roads of commerce crossed at the village that had developed near the farmstead settled by Alexander Schaeffer and his family as early as the mid-1730s. By 1763, a village had developed that, by the 1780s, became well known due to a far-sighted entrepreneur by the name of Samuel Rex. Myerstown, however, had its share of entrepreneurs, especially after the opening in 1827 of the Union Canal that passed through it. There is documentation that the very first attempt at building a canal in the new nation was under way near Myerstown in the early 1790s when Pres. George Washington visited his friend Col. Michael Ley two miles west of Myerstown to observe its progress.

The Union Canal, with its tunnel completed, was in operation by 1827. Myerstown began to grow as its businesses took advantage of the canal to market the region's natural resources. Mills using waterpower flourished along the creek and canal, as did feed and lumber businesses. When a railroad was built through the heart of the valley in the mid-1850s, new commercial ventures emerged, such as the horse farms of Jacob Baney and the foundries that produced metal parts and accessories needed by industries in the larger cities during the nascent industrial decades following the Civil War. By the 1890s, when the picture postcard emerged as a form of communication, Myerstown had become an educational as well as a commercial center for eastern Lebanon County. Palatinate College, founded in the late 1860s, emerged in 1895 as Albright, which became a more enduring institution. The canal was gone by this time, but a turnpike—the Berks and Dauphin—that had been channeling commerce and travelers through the valley since 1817 laid the course for a system of roads that would eventually become highways. Sometime in the 1920s, the main street of Myerstown became the Benjamin Franklin Highway.

Other towns in eastern Lebanon County also continued to grow and prosper during the 19th century, with the exception of Millbach, which has retained its 18th-century ambiance. Cigar-making, often in small factories and private homes, sustained family budgets. Kleinfeltersville, Newmanstown, Richland, and Schaefferstown all had a share in this industry, now gone with the changing tastes and times. Garment factories, likewise, mostly are gone from the towns of eastern Lebanon County. Their factory buildings are filling up with craft and collectible shops, and with youth- and service-oriented organizations, often with ties to religious groups. Musical organizations, such as the town bands of a century ago, have become dependent upon the schools for parades and concerts. Fire companies, then as now composed of volunteers, however, have become more important to community life, safety, and health due to their various auxiliary and ambulance services. Sports teams in the local towns are as popular today as they were a century or more ago—a time when the medium of the picture postcard emerged as a legacy from America's World's Fairs and the democratization of photography.

This book features photographic cards produced during the "Great Post Card Craze" of 1905–1914 and the decades following. Real-photo postcards were not produced in the thousands per image, as were the lithographically printed colored postcards of the time. Their production depended upon the number of family and friends one had and the amount of extra cash in one's pocket. Real-photo postcards have always been more accurate than those printed lithographically, because they sprouted as grass roots from local photographers in communities of every size, and at times from the cameras of individuals working at home.

Read and recall, look and learn, sit back and enjoy Myerstown and eastern Lebanon County through photographic postcards from the first half of the 20th century.

One

MYERSTOWN
THE STREETS OF YESTERYEAR

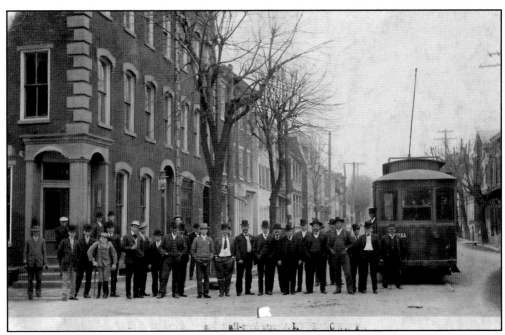

A group of citizens, many of them local businessmen, posed for a picture in front of the Bahney House in 1907 when the streetcar from Lebanon arrived. This intersection of Main and Railroad Streets in Myerstown was the easternmost point of the Lebanon Valley Street Railway.

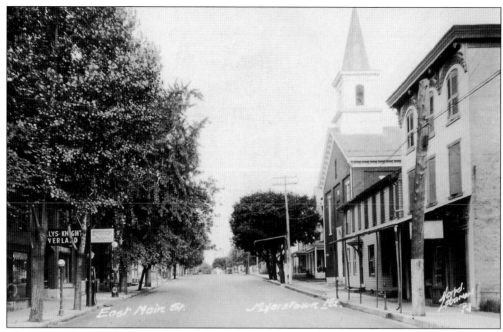

This 1928 photograph looks east on Main Street, a short distance from Railroad Street. On the right is Frantz Bros. and the United Brethren Church. Across the street was a dealer selling Ford, Willys-Knight, and Overland motor cars.

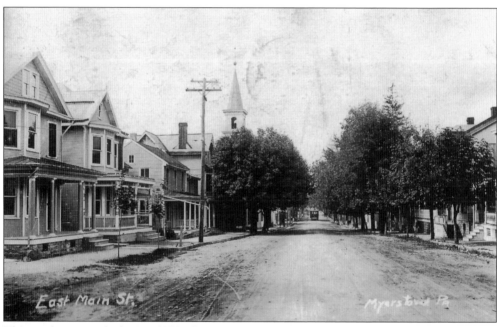

This card, postmarked May 1921, shows East Main Street in Myerstown, looking west past the United Brethren Church. The trolley in the distance is at Railroad Street. (Courtesy of Nancy Gambler.)

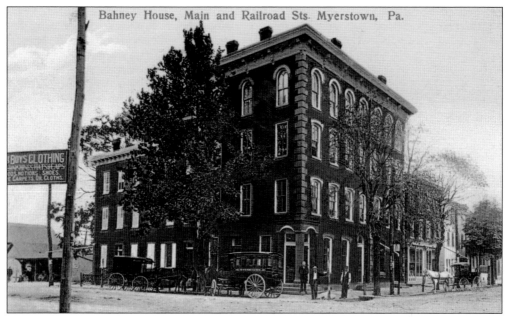

Shown here is the Bahney House in 1910. The automobile age had already dawned, but horse-drawn carriages were still the norm. Carriage sheds and stables can be seen to the left. The carriage at center is that of Charles Schaeffer. He operated the Myerstown Omnibus, which carried passengers between the railroad station and the Bahney House, one-half mile north at the center of town. (Courtesy of Terry O. Schott.)

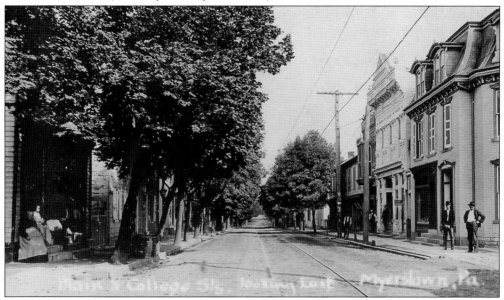

This view of Main Street, looking east from College Street, is from 1910, the year that Myerstown's second bank, Farmer's Bank & Trust, opened. The bank, seen at right with the mansard roof, was reorganized as Myerstown Trust Co. in 1914, and operated at this location until 1953, when Lessig's Clothing Store located there. The tall white building, displaying the year 1853 on its Victorian facade, housed the post office some years before 1924, and at the time of this photograph was William Martin's tailor shop.

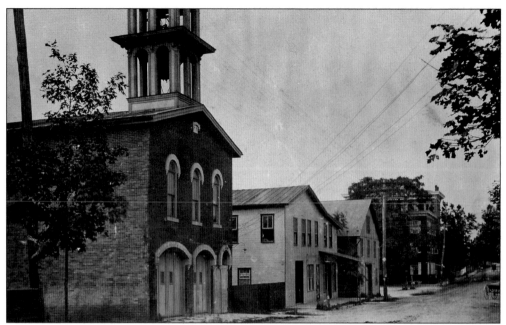

This is the west side of South Railroad Street, looking north from Carpenter Street, in 1910. The buildings here are, from left to right, the 1875 Keystone Hook & Ladder Co. No. 1 firehouse; Myerstown's Market House, which operated until World War II; a livery stable (site of Myerstown's post office by 1924); and, in the distance, the Bahney House at Main Street.

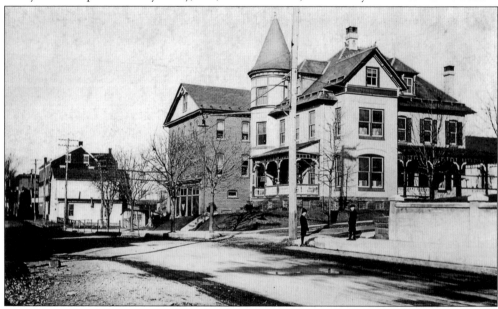

This 1918 view of the east side of South Railroad Street, looking north from Carpenter Street, shows, on the corner, the home built by Henry Peiffer in 1893. By the 1940s, this would be the Earl Wilhelm family home. Next to this is the Wilhelm Hardware Store. The building was erected in 1904, but the business, begun by John Henry Wilhelm, dated to 1881. In the distance, the taller, balloon-frame building became Adam Hoffman's Lunchroom, locally called the "Doggie Shop." (Courtesy of Jack L. Kiscadden Jr.)

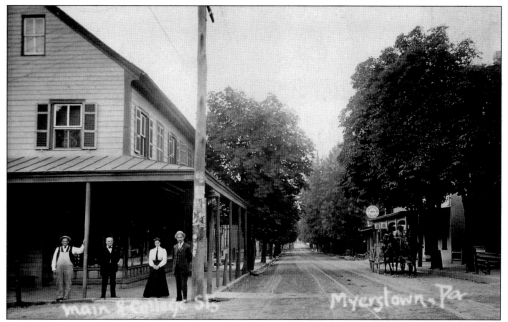

A 1909 postcard of Main Street, looking west from College Street, shows the Musser and Tice General Merchandise store on the southwest corner and a horse-drawn wagon in front of the Franklin House across the street. The Franklin House was one of six hotels in Myerstown in 1909. Proprietors of the store stand outside. Charles and Tillie Line operated the store for four decades following World War I.

This photograph, also facing west on Main Street from College Street, was taken 40 years after the above image. The merchandise store, second building from the left and popularly known as "Tillie Line's," stood until it was dismantled in the late 1990s. Across the street on the right is Bahney's Furniture Store, at the northwest corner of Route 501 and Main Street. Bahney's had been established as an undertaking and furniture business in 1834 and was America's oldest furniture store when it shut down operations in the autumn of 2011.

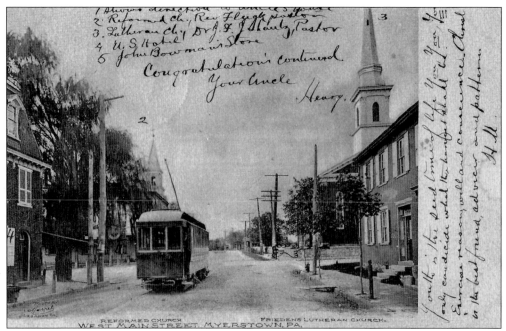

Henry U. (Urich) mailed this card to Mary E. Powers in Lancaster, Pennsylvania, on November 26, 1906. "Uncle Henry" identified the buildings shown at the intersection of Main and Locust Streets on Myerstown's west end. The steeples of two churches, the Reformed (left) and Lutheran (right) are visible. The United States Hotel, built by Simon and John Bassler, is on the far left, and their saddler's shop is on the right. Behind the trolley traveling west to Lebanon is John Bowman's general merchandise store built in 1848–1849 for Thomas Bassler.

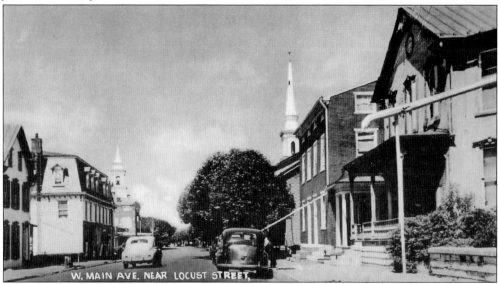

This photograph of the same view as above was taken 40 years later. The United States Hotel has retained its mansard roof. Bowman's Store ceased operating in 1929 and, by the late 1940s, housed Nora Yost's Pennsylvania Dutch Gift Shop & Ice Cream parlor. In 1993, the Institute of American Deltiology, a postcard research center and gallery, was established at this location by Donald R. Brown.

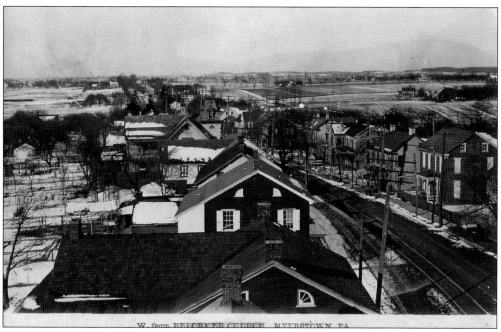

This 1908 view, looking west from the steeple of the Myerstown Reformed Church, follows Main Street toward West Myerstown. The house just above center, with the Victorian tower, was that of Civil War captain John H. Bassler, who organized a company of volunteers (Second Bucktail Regiment) in 1862 and was wounded at Gettysburg. The photograph was taken by Daniel A. Holtzman.

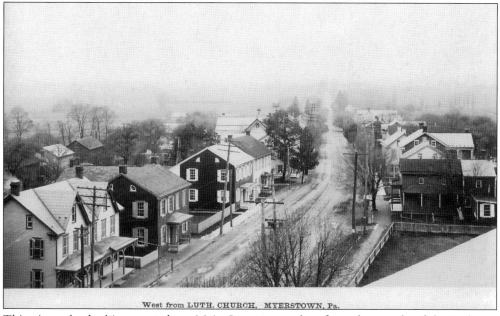

This view, also looking west along Main Street, was taken from the steeple of the Lutheran church, across the street from the Reformed church. Streetcar tracks are visible on the unpaved street. Daniel A. Holtzman had taken this photograph from the base of the steeple. (Courtesy of Nancy Gambler.)

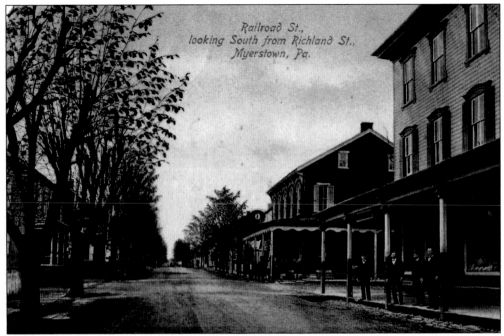

Corl and Manderbach's Dry Goods Store is seen on the right at the intersection of Railroad Street and Richland Avenue in 1908. Beyond is the hotel built in 1874 by Samuel Crouse, well known as a comb maker. He owned land north to the Tulpehocken Creek, where he built a flour mill, which was later J. Swonger's. By the 1920s, Carson Brightbill owned both the store and the hotel, which was converted to a farm implements store.

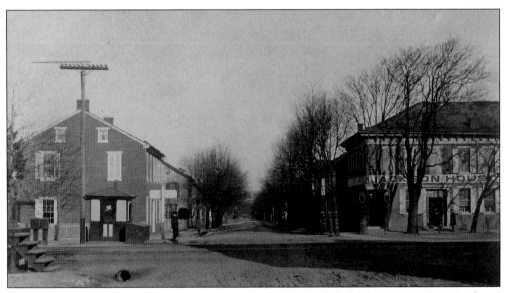

This 1906 view faces north on Railroad Street from the Philadelphia & Reading Railroad tracks. On the left can be seen the watchman's shed, and on the right is the Jackson House, one of Myerstown's six hotels at the time. The Jackson House operated until the early 1930s. Still standing in 2012, this building is an apartment house.

Two

MYERSTOWN
CHURCHES AND HOMES

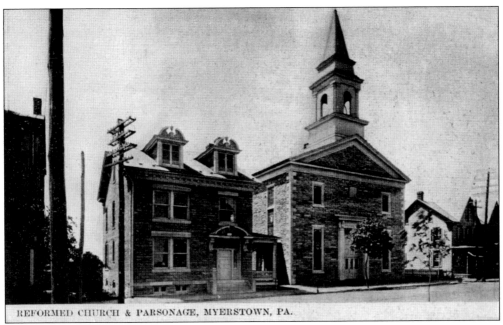

REFORMED CHURCH & PARSONAGE, MYERSTOWN, PA.

The German Reformed Church was built of local limestone in 1854–1855 along the Berks and Dauphin Turnpike (Main Street) on the west end of Myerstown. The parsonage (left) was built in 1907 and converted into church offices in 2011. The current pastor lives in the house on the right.

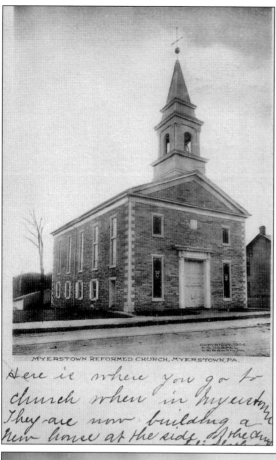

MYERSTOWN REFORMED CHURCH, MYERSTOWN, PA.

Here is where you go to church when in Myerst... They are now building a new house at the side of the...

Established as a branch of the Tulpehocken Reformed Church two miles east, this building was dedicated on September 30, 1855. In 1860, it was organized as a separate congregation. It was called Evangelical & Reformed from 1934 until 1957, when that denomination merged with the Congregational Christian churches to form the United Church of Christ in America (UCC).

Built in 1848 by Peter Stoudt in classical vernacular style for Thomas Bassler, an entrepreneur with several businesses along the Union Canal, this building at West Main and Locust Streets housed the mercantile store of Moses Bowman and his family from 1867 until 1929. By the 1940s, Nora Yost operated a gift shop and sold ice cream here. In 1993, Donald R. Brown established here the Institute of American Deltiology, a research facility for the display, study, and use of picture postcards.

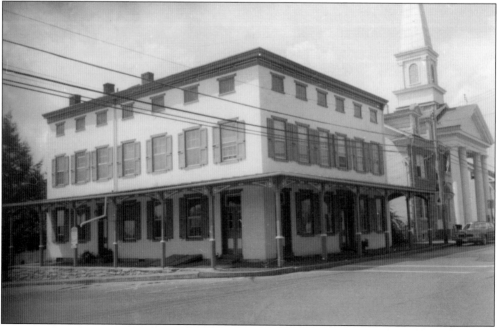

Friedens Evangelical Lutheran Church, on the northwest corner of Main and Locust Streets, is seen here without the small front vestibule added by 1909 (seen in the image below). The original, 1812 stone church was replaced by this spired brick structure in 1857–1858, and it stood until 1960, when a larger edifice was erected one block north.

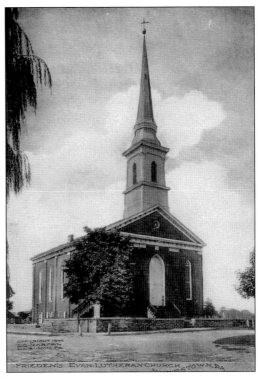

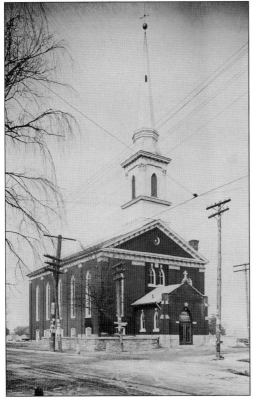

Friedens is the oldest religious congregation in Myerstown Borough, having been founded in 1811–1812 under the leadership of John Andrew Schultz, who would later serve as governor of Pennsylvania (1823–1829). Michael Lei and Leonard Immel, officers in Washington's Continental Army, were early trustees. (Courtesy of Terry O. Schott.)

19

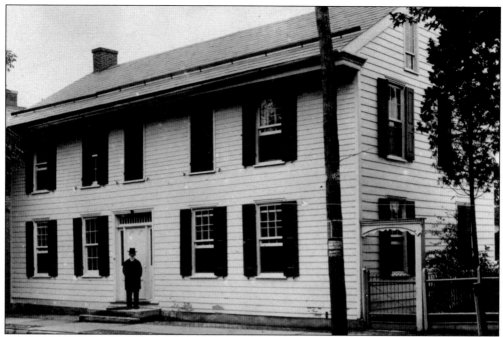

Standing at the entrance to the Lutheran parsonage in 1906 is the Reverend F.J.F. Schantz, DD, longtime pastor of Friedens church (1867–1907). This is one of Myerstown's earliest structures, built when the village was known as Tulpehockentown. It was a tavern, the Henry Buch House, where the town's founder, Isaac Meier, was mortally wounded on July 13, 1770, by an assassin. (Courtesy of Myerstown Community Library.)

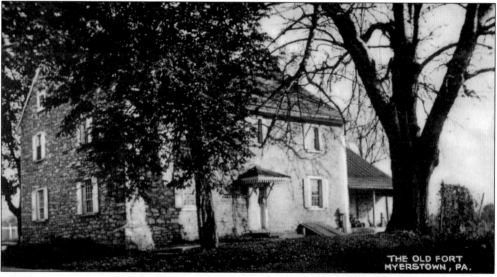

The Isaac Meier homestead is shown here in 1947, when it was popularly referred to as "The Old Fort." Since 1968, efforts have been made by a preservation committee, Isaac Meier Homestead, Inc., to maintain the property as a community resource for the appreciation of local heritage and as an architectural laboratory. The original house was built in the 1740s by the Valentine Hergelrode family. By 1757, it was owned by Isaac Meier and his wife, Catharine, a daughter of Mr. Hergelrode.

Zion United Brethren Church, at 22 East Main Street, was built in 1869–1870 and used until 1974, when a modern structure replaced it. The congregation dates to 1843 due to the efforts of Rev. Samuel Enterline, a circuit rider. Called the Evangelical United Brethren Church after 1946, the denomination merged again in 1968 when it became the Zion United Methodist Church.

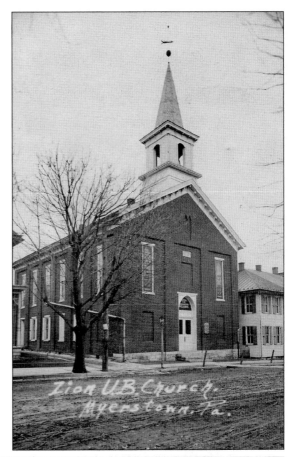

The furniture in the Sunday school chapel of Zion United Brethren Church is reminiscent of that in many other Protestant church Sunday school rooms and social rooms in the Lebanon Valley a century ago.

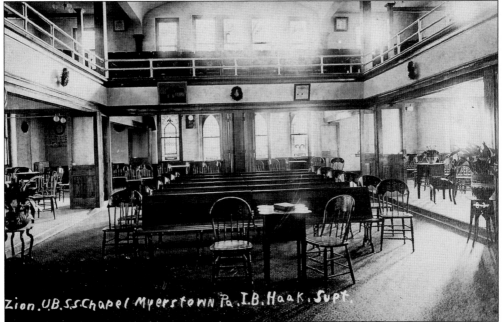

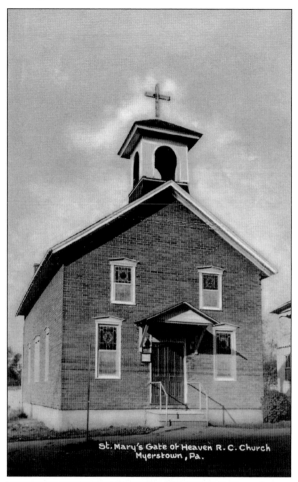

St. Mary's Gate of Heaven R. C. Church
Myerstown, Pa.

Mary Gate of Heaven Roman Catholic Church, dedicated in December 1926 by Bishop McDevitt of Harrisburg, was named by an anonymous benefactor from Chicago who gave funds to purchase the Miles Becker grain warehouse, at Center and Railroad Streets. Started as a mission of St. Gertrude's, Lebanon, the church was founded to serve Italian Americans who had emigrated from the Province of Abruzzi to work in the area's limestone quarries. In the 1970s, this structure became home to the Myerstown Jaycees.

Built by John Bollinger around 1908, this house at 515 South Railroad Street has, in recent decades, been associated with the Ebling family, who operated a meat market until 2006 in the Bollinger butcher shop, seen to the right. In 1908, water was still flowing through the old Union Canal prism. Lock No. 10 was out of this view to the right. (Courtesy of Terry O. Schott.)

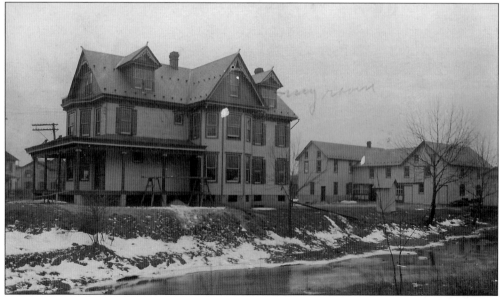

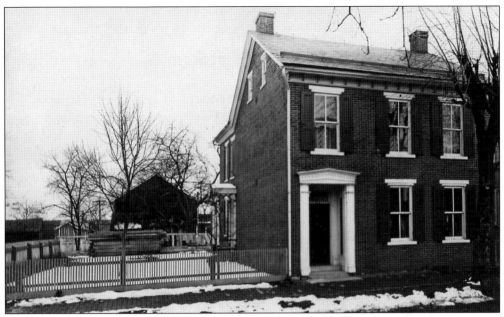

Typical of Pennsylvania German townhomes is this one at 714 South Railroad Street, where the Earl Bordner family lived in the early 1900s. Built with brick around 1880, the house was flush to the front walk. Backyards with boxed vegetable gardens and boardwalks leading to small barns at rear alleys were the norm.

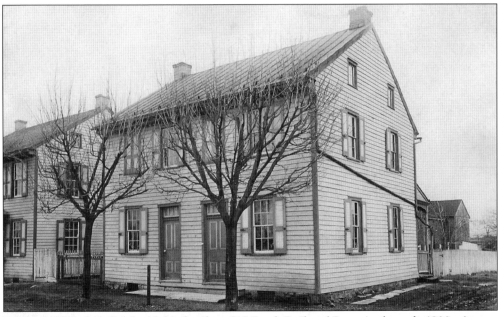

Daniel A. Holtzman lived with his family at 819 South Railroad Street in the early 1900s. A news dealer, grocer, former country school teacher, and photographer, Holtzman produced many real photographic postcards of Myerstown-area places, activities, and people prior to World War I.

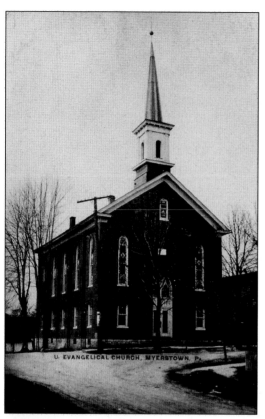

This postcard shows Zion United Evangelical Church as it appeared in 1909. It was built in 1877, after a storm had unroofed its 1844 building west of Old Union Cemetery. Sans the steeple spire, it still stands at College and Carpenter Streets. It was the college church when Albright was located in Myerstown. Since 1929, it has been affiliated with the Evangelical Congregational Church, a denomination whose national offices and seminary (Evangelical Theological Seminary) are located nearby, on the former site of Albright College.

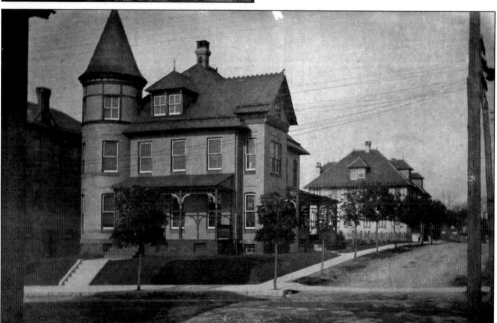

Built in 1893 by Henry Peiffer, this modified Queen Anne–style house was the Earl Wilhelm family residence by the 1940s and, by the 1970s, housed the offices of Dr. Peter Hottenstein. The view is to the east, up Carpenter Avenue from Railroad Street.

The home of Isaac and Agnes Bahney, at 32 West Main Street, is seen here. Their son Edgar is standing on the front porch about 1911. Isaac N. Bahney was a furniture dealer and undertaker whose businesses were located on the northwest corner of Main and College Streets. Several generations of his descendants operated the furniture store until 2011.

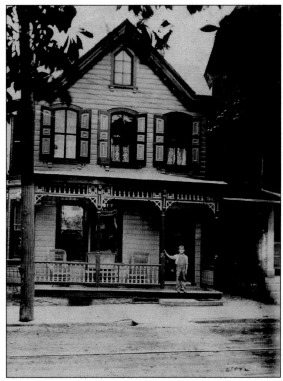

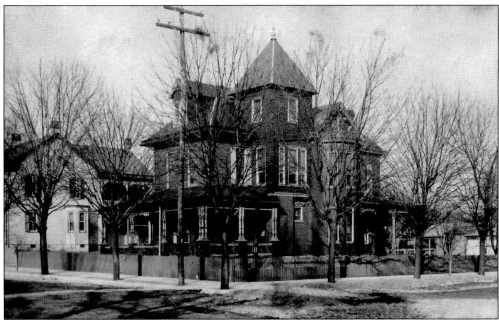

Seen here is the Joseph Painter–Carl Karmany house on the northeast corner of Bahney Avenue and Railroad Streets. It was built around 1900 by Joseph Painter, who brought his foundry to Myerstown in 1872. His granddaughter Margaret (Mrs. Carl Karmany) established the county's first two Girl Scout troops: Lebanon's in October 1919, and Myerstown's Bluebirds in November 1919. Today, this is the home of the Scott and Michelle Houtz family.

This double house at 112–114 North College Street is typical of frame residences built prior to the 1920s in Myerstown and the other eastern Lebanon County towns. Rows of double-frame houses with yards mainly to the rear were constructed by landowners in need of more income.

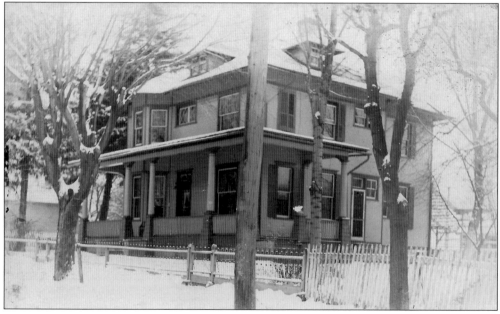

The Bright and Elizabeth Lindenmuth home is seen here on a winter day in 1911. Located at 370 West Main Street, at South Race Street, the home's current resident is Agnes Bender. Max and Kristin Bender operate Choice Communications, a business communications service, from rear buildings on this property.

Three

Myerstown

Schools, Sports, Firehouses, and Bands

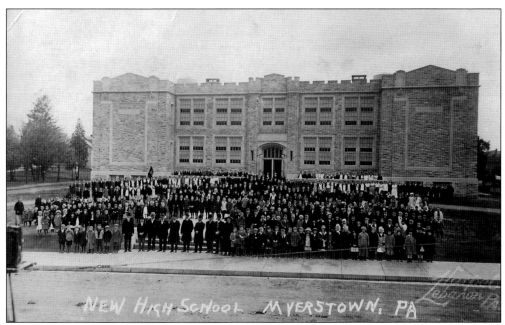

Students and faculty pose for a photograph in the fall of 1915 at the opening of Myerstown's third high school. The building, of limestone construction, was located on Railroad Street. An addition was built in 1935–1936 containing chemistry and home economics laboratories, a library, and mechanical and woodworking shops. Myerstown hosted a well-known community fair on the school grounds from 1934 until 1958. When a consolidated Eastern Lebanon County High School opened south of the town in 1962, this building became an elementary school.

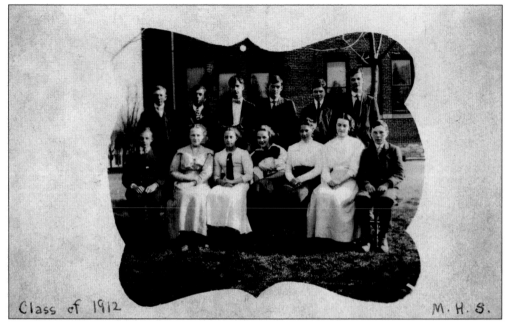

Class of 1912 M. H. S.

The Myerstown High School class of 1912 poses for a photograph. A century later, in the fall of 2011, the building, at Park Avenue and Railroad Street, was demolished. Shown here are, from left to right: (first row) I. Noble Dundore, Nora Yost, two unidentified, Violet Line, Hattie Schoener, and unidentified; (second row) Raymond H. Brown, Earl Helms, unidentified, Lloyd Yost, Paul Wolff, and George Karsnitz.

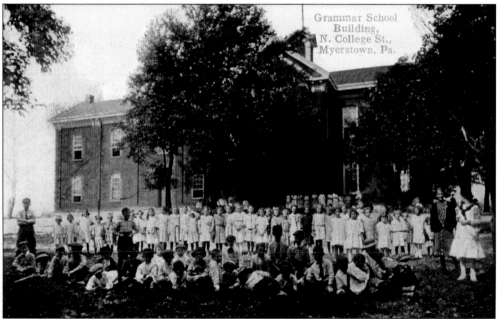

Myerstown's Grammar School students and faculty posed for Luther Harpel on the school's North College Street grounds in 1908. Built in 1885, the "Hill School" stood until 1969, when a new community library was built on the site. From 1885 until 1895, this was Myerstown's first high school when all 12 grades attended here. From 1895 until 1962, this was an elementary school.

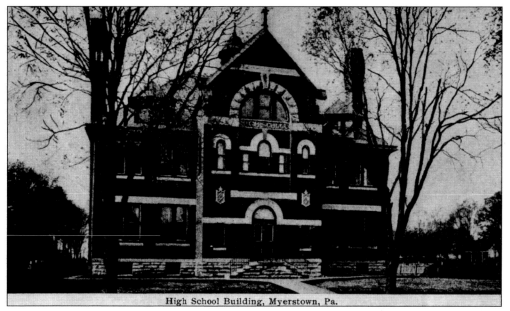

High School Building, Myerstown, Pa.

Myerstown's second high school was built in 1895 on the northwest corner of Park Avenue and Railroad Streets. When a new, graystone high school opened up on the street, this structure was sold to Albright College in 1915 to house its biological laboratory. From 1936 until 1954, the Myerstown Community Library was located here. After that, the Evangelical Congregational Church used the building for various purposes, mostly as a nursing home, until it was demolished in the fall of 2011.

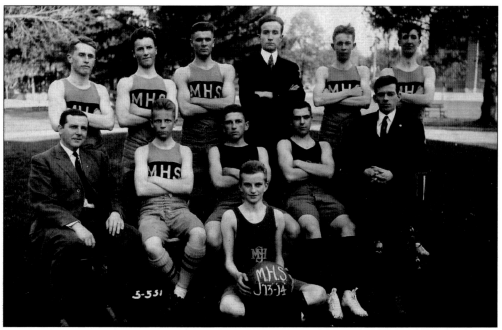

Seen here are the players and coaching staff of the Myerstown High School basketball team of 1913–1914. If anyone recognizes any of the team members, please contact the author.

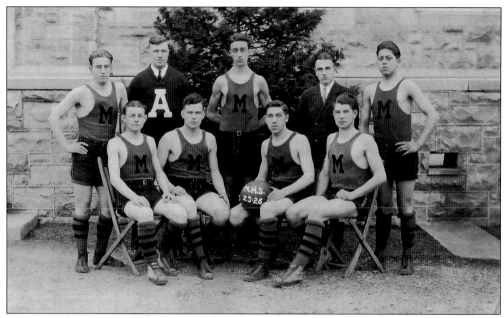

The Myerstown High School basketball team of 1925–1926 poses for a photograph. Coach Sheeley was proud of his connection to neighboring Albright College. Pictured second from the left in the first row is Alvin Youse and third from the left in the second row is Rocco Ranaldi.

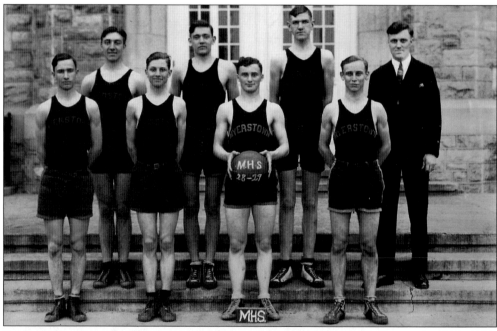

Professor Sheeley was still coaching Myerstown's high school basketball team in 1928–1929. Posing for a team photograph are, from left to right: (first row) Robert Schaeffer, Harry Keeney, Melvin Lehman (captain), and Kermit Mohn; (second row) Millard Webber, Morris Bicher, Frederick Snoke, and Sheeley.

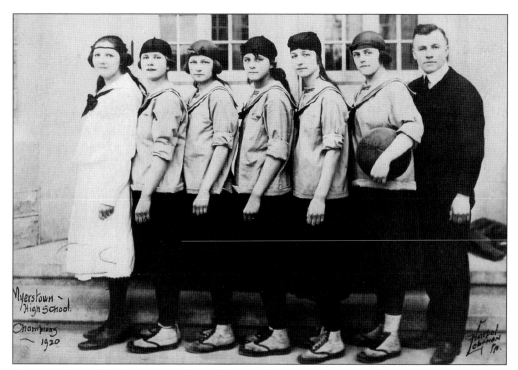

The members of the Myerstown High School girls basketball team and their coach pose here as 1920 county champions. Mildred Bordner (later Mrs. George Wolff), captain, is at the far left. The other persons shown are unidentified.

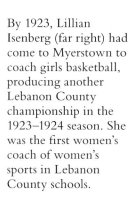

By 1923, Lillian Isenberg (far right) had come to Myerstown to coach girls basketball, producing another Lebanon County championship in the 1923–1924 season. She was the first women's coach of women's sports in Lebanon County schools.

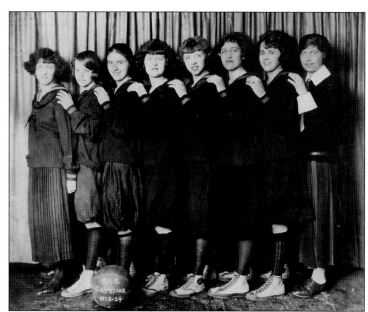

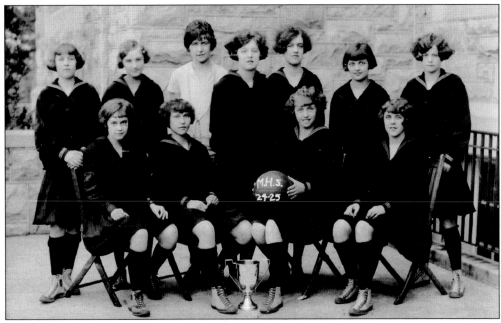

Lillian Isenberg (second row, third from left) guided the Myerstown High girls to a second county basketball championship in 1924–1925 before becoming Mrs. Edgar N. Bahney. In 1981, Lillian Isenberg Bahney was elected to the Pennsylvania Sports Hall of Fame.

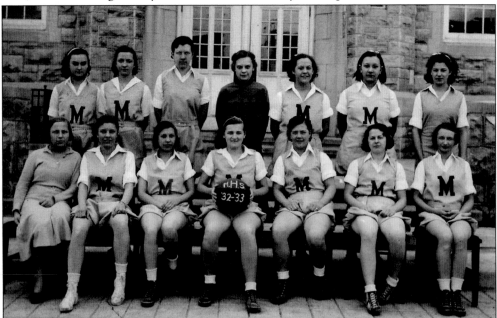

Women's basketball has remained a strength of Myerstown High School sports through the years. Here is the team of 1932–1933, when Catherine Steltz was coach. Shown here are, from left to right, (first row) Ruth Allwein Fogelman, Marjorie Smith, Irene Risser Geib, Eunice Lehman (caption), Pearl Urich Yeiser, Edith Albert, and Lillian Arnold Youse; (second row) Helen Salem Garrett, June Krum Yeagley, Margaret Lockhart Loose, Coach Steltz, Aerietta Crouse Mentzer, Mary Anna Yeiser Bugg, and Jeanette Yarnell Preminger.

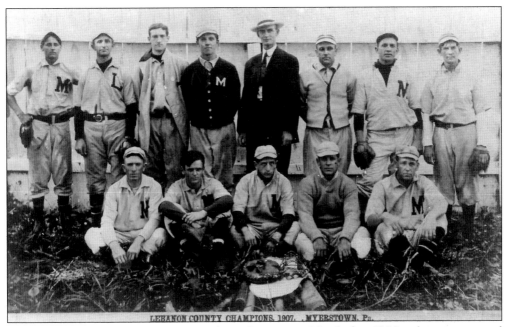

Baseball teams in Myerstown were in independent competition before 1900 and were sponsored by industries as well as organizations. This team, coached by George Bleistine Sr. (in straw hat) and including Charles "Pop" Kelchner (second row, second from left), was sponsored by the Keystone Hook & Ladder Co. The team was Lebanon County champions in 1907.

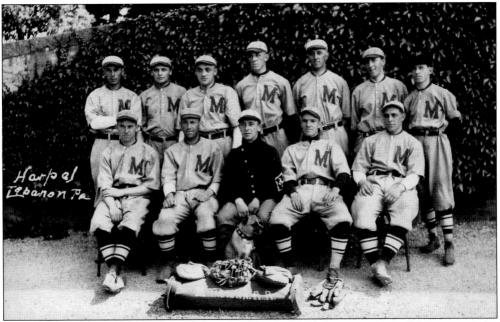

Members of the town's baseball team are seen here with their mascot, a bulldog, around the time of World War I. In the second row, John Swanger is on the right and Warren Yeiser is third from right.

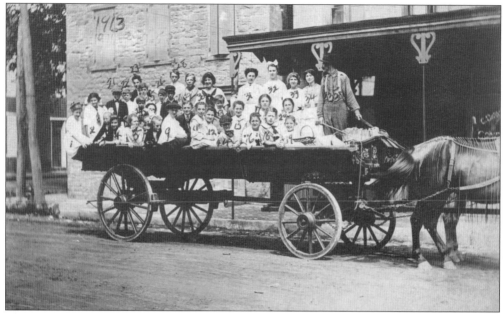

A wagonload of 34 local young folks is out for a ride in 1913 with Ed Scholl holding the reins. The limestone structure with the closed shutters was the Allen Weigley Building, the rear of which housed the Myerstown jail. The structure on the right housed Charles Holtzman's Confectionery & Ice Cream Parlor. Both buildings have been demolished.

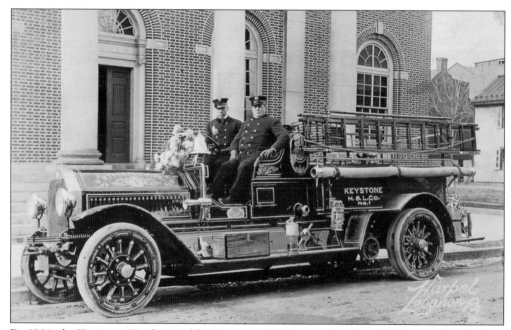

By 1916, the Keystone Hook & Ladder Co. owned a Seagrave truck, which is seen here in front of Lebanon's post office. Ed Beckey is in the driver's seat.

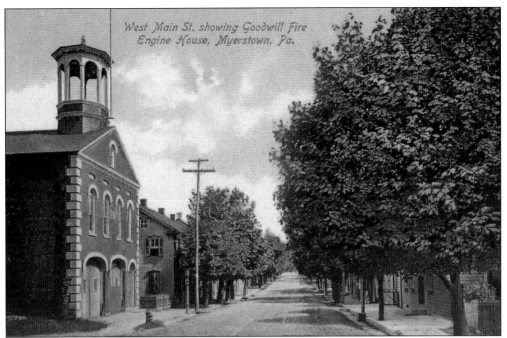

This 1909 postcard features the Goodwill Engine Hose Co. hall, built in 1875 and located on West Main at Goodwill Street. The fire company had been organized in 1867–1868 with Dr. Frank Bowers its president. The company's name since 1938 has been Goodwill Fire Co., No. 1. In 2011, a new, larger firehouse with an engine tanker station, No. 80, was built on West Washington Avenue at North Locust Street. The 1875 hall is now home to the Goodwill Fire Police.

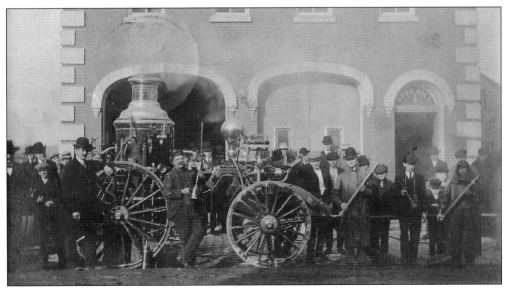

By 1883, Goodwill's original fire apparatus had been replaced with a Silby steamer. Rebuilt in 1901, it is shown here in front of the hall on a 1907 postcard.

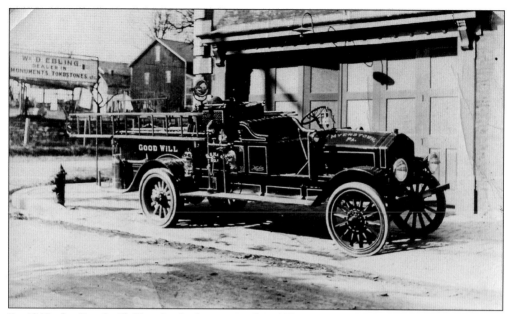

By 1919, the Goodwill Fire Co. had motorized its Silby steamer to the state shown here, had purchased a chemical truck, and dedicated both with a big parade that August. Seen across Goodwill Street is the Wm. D. Ebling Marble & Granite Works, located there from 1905 until 1924, when the business was moved to Lebanon.

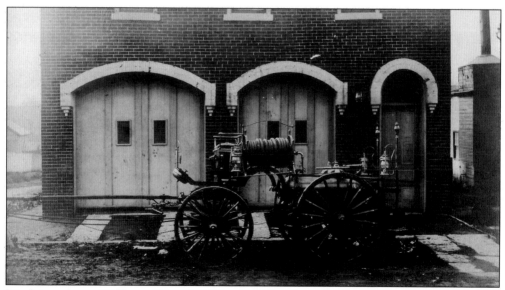

The horse-drawn Holloway Chemical Wagon of the Keystone Hook & Ladder Co., pictured here on a 1906 postcard, was motorized in 1922 and fitted onto a Ford chassis. The wagon was used until 1940.

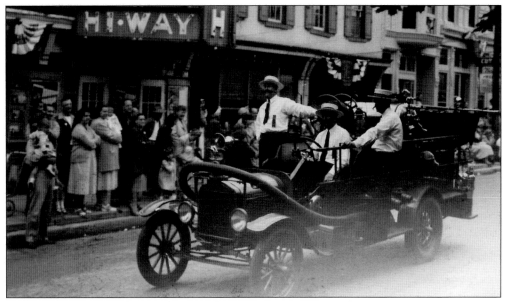

In June 1952, the Lebanon County Fireman's Association held its annual convention in Myerstown. The parade is seen passing the Hi-Way Movie Theatre on Main Street, a few doors east of College Street. From the 1920s, when it was called the Majestic, until it closed in 1956, the Hi-Way showed three different movies each week. In earlier years, movies had been shown in Myerstown at the Keystone Fire Hall and in a building that later became the Witter Cigar factory on West Carpenter Avenue. (Courtesy of Jack L. Kiscadden Jr.)

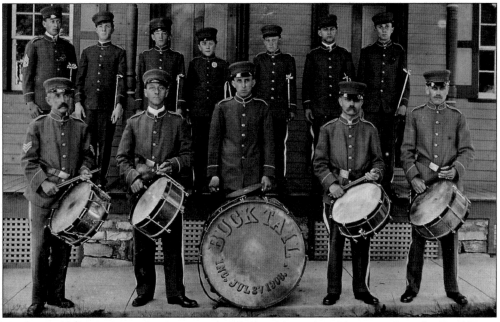

The Bucktail Fife & Drum Corps was organized in 1903 and took its name from the Civil War–era Bucktail Regiment of the Union Army (Myerstown had supplied a full company). There is no record of how long the Fife & Drum Corps lasted. Several of the members were Bucktail Regiment veterans. (Courtesy of Nancy Gambler.)

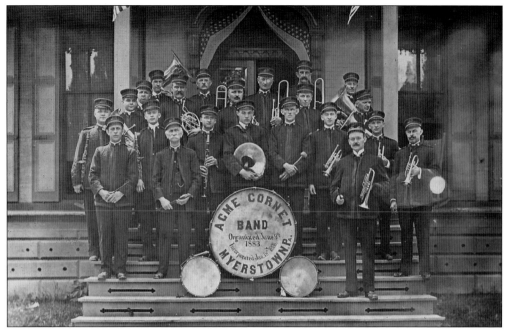

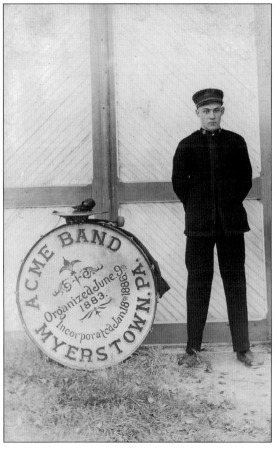

Myerstown's Acme Cornet Band, organized in 1883, posed on the steps of Albright College's Mohn Hall in 1913. David T. Bordner, director, stands at extreme right. Acme's limestone band house, a former schoolhouse and now a private home, stands on North Railroad Street. Surnames of the members are a roll call of Myerstown's musical families: Arnold, Bomberger, Bordner, Loeb, Huber, Kochenberger, Keeney, Kiess, Kutz, Moyer, Phillips, Risser, Rummel, Schoener, Stauffer, Stover, Urich, and Tommy Yiengst.

L.P. Rummel is shown in 1913 standing by his bass drum, which dates the founding of the Acme Band to 1883. The date of the band's demise is less definite, but it is known to have ended its playing days by the early 1930s.

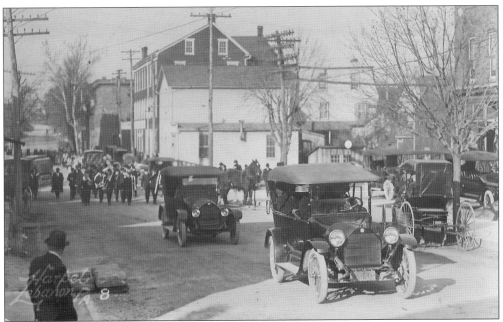

Either late in 1918 or early the next year, Myerstown staged a parade, which proceeded south on Railroad Street from Main Street. Marchers represented various causes—the Red Cross, women's suffrage, peace. Armistice Day ending World War I had occurred on November 11, 1918. (Courtesy of Lebanon County Historical Society.)

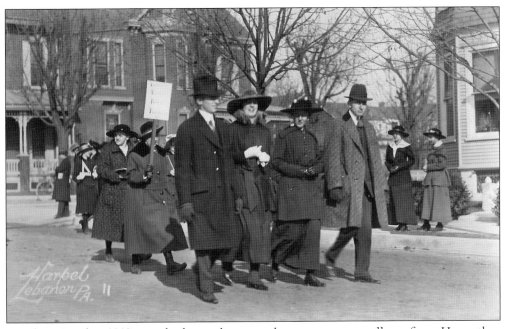

Marchers in the 1918 parade knew how to dress warm as well as fine. Here, they have just passed East Bahney Avenue and are heading south on Railroad Street. (Courtesy of Lebanon County Historical Society.)

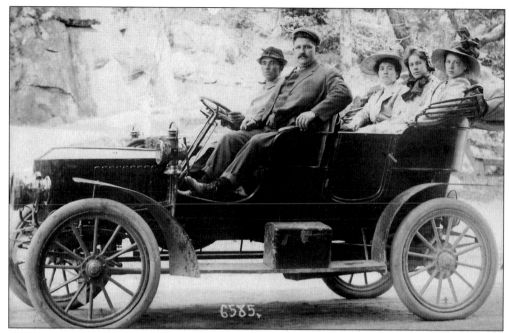

One of the first automobiles—a Stanley Steamer—is seen here, with Harry Kohl, left, at the wheel and Will Zeller seated next to him. In the backseat are, from left to right, Amelia Kohl, Tama Zeller, and Mamie Weidner.

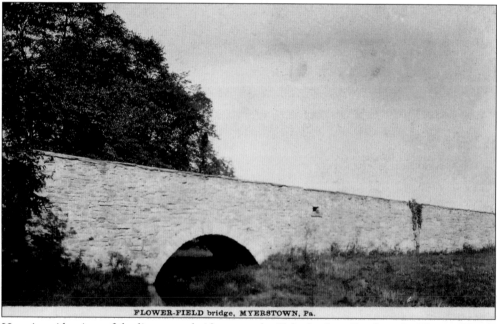

FLOWER-FIELD bridge, MYERSTOWN, Pa.

Here is a side view of the limestone bridge over the Tulpehocken Creek at the Flower Woods on South Locust Street. This bridge, believed to have been built in the 1790s, is unique in that it lacks a keystone. Water from the creek no longer flows under this bridge. The former Union Canal bed, a few hundred feet to the north, has carried the creek for the past century. The Union Canal had ceased operating by 1885. (Courtesy of Terry O. Schott.)

Four

MYERSTOWN
BUSINESS LIFE AND INDUSTRIES

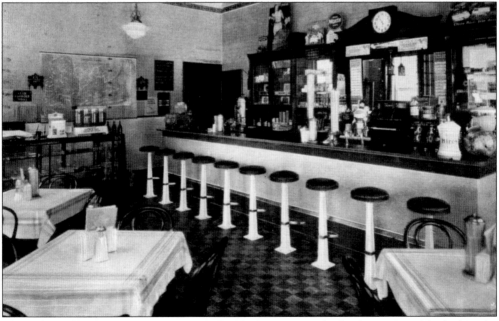

This is how the corner lunch counter and soda fountain inside the Frantz Hotel looked in the 1930s. Hot and cold sandwiches, pies from Albert's Bakery, Hires Root Beer, Coca-Cola, and Moxie, the drink that gave Americans a confidence and style, were available, along with great coffee and hot fudge sundaes. In the late 1940s, the Frantz Hotel reverted to its earlier name, Bahney House. As of 2012, the hotel is undergoing a restoration.

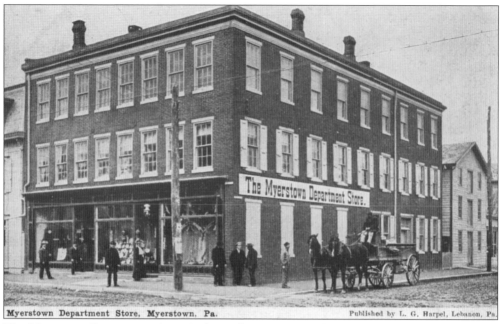

Myerstown Department Store, Myerstown, Pa. Published by L. G. Harpel, Lebanon, Pa.

The Myerstown Department Store is shown here in 1905, when Levi Hess (far left) owned it. Seated on the wagon is Andy Dehart. In the 1920s, this store was operated by Charles Moyer. Under Louis Reinhold in the 1940s, it became a grocery store. The Fred Fulk family owned this building and operated it as the Buy-Rite Food Market from 1948 until 2008, when son William "Billy" Fulk retired. Today, a collectibles shop is located here.

Myerstown had a market house where area farmers sold produce and meats until World War II. It stood north of the Keystone Hook & Ladder hall on Railroad Street. The manager of the market is standing outside in this 1911 photograph.

In 1911, this tall, narrow building with terra-cotta ornamentation at 54 West Main was the tailor shop of William Martin. Neighborhood youth, Lottie Smith Culp (white dress), and a Sherk baby are seen. Today, this building is owned by the Ebling family. Next door stands a larger building with even more terra-cotta work and a parapet that contains the dates 1853 and 1890. The Sugar Bowl Restaurant occupied that space in the 1940s and 1950s.

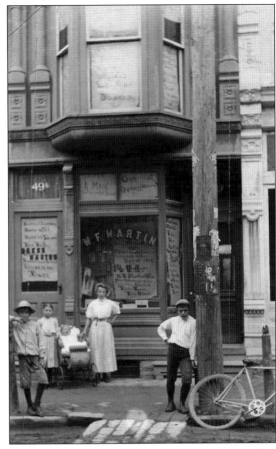

This building at 113 West Main Avenue was the home and mercantile store of John Andrew Melchior Schulze when he moved to Myerstown from Berks County in 1804. In 1806, he was elected to the state legislature and served three terms. Gov. Simon Snyder appointed him to five key positions in the new county of Lebanon (formed February 16, 1813), and Schulze moved to the city of Lebanon. From 1823 to 1829, he served two terms as governor of Pennsylvania. This building still stands today. (Courtesy of Myerstown Community Library.)

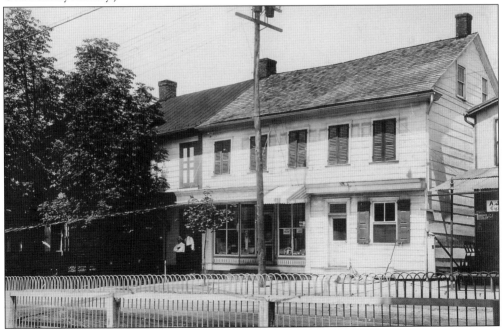

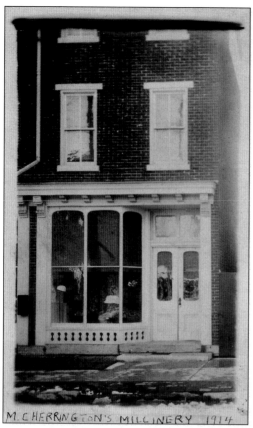

M. Irene Cherrington's Millinery Shop was located at 8 West Main Street in 1914. Myerstown has had several stores for women through the years, including that of Sara Blatt's at midcentury. (Courtesy of Myerstown Community Library.)

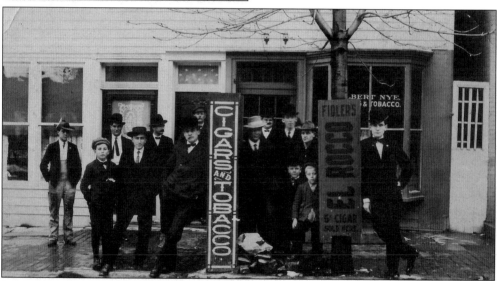

Here are the town swains of 1906, standing in front of Albert Nye's first cigar store, located three doors west of the Bahney House. The Schell Building later occupied this site. Shown here are, from left to right: (first row) Eddie Kohl (in cap), A. Moyer, I. Moyer, J. Eckert, J. Donald Reiter (boy), Pat Kutz, Ray Smith (boy), and George Leibig, leaning against a sign; (second row) C. Helder, Ervin Kohl, E. Swonger, J. Bordner, Al Nye, and W. Yiengst.

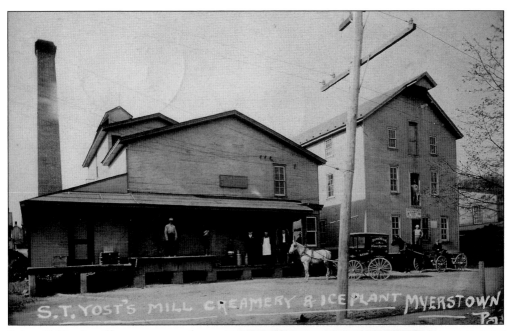

S. T. YOST'S MILL CREAMERY & ICE PLANT MYERSTOWN Pa.

Salem T. Yost's mill, creamery, and ice plant are depicted on this real photographic postcard from 1911. A sign for Hammond Dairy Feed is on the building at right, and the side of the wagon advertises the firm's "pure milk" and "fancy butter." By the 1920s, the Hershey Chocolate Company operated a creamery on this street until the 1950s. For many years, this street, currently Center Avenue, was called Creamery Street.

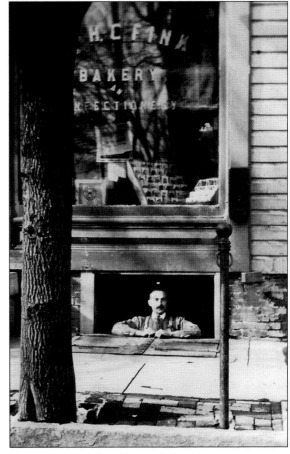

Harry C. Fink, grocer and baker, appears from his basement bakery at 55 West Main Street on a day in 1914. (Courtesy of Jack L. Kiscadden Jr.)

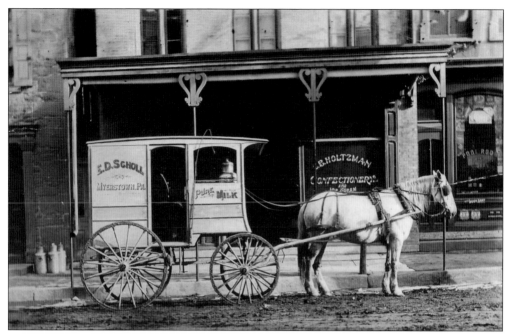

Ed Scholl is sitting in his horse-drawn milk wagon in front of Charles Holtzman's Confectionery at 3 East Main Street around 1907. The pool hall on the right was operated by Claude and Wally Salem. The Holtzmans made delicious ice cream, but the product that made the family a part of American food lore was the "pretz-stick." George Holtzman invented a machine in 1912 to produce straight pretzels. (Courtesy of Joel J. Wiest.)

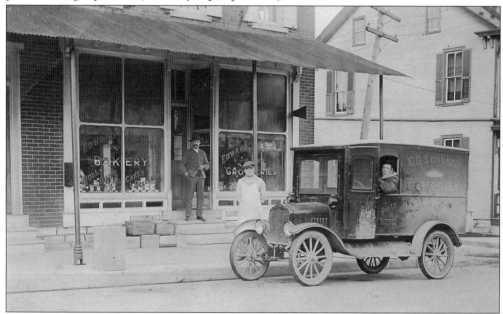

By the early 1920s, Ed Scholl was operating this bakery and grocery store at 225 East Main Street. He is standing in the store's doorway, and his son Paul is in the truck. By the 1940s, Snyder's General Store was located here. Ed Scholl had gone off to Washington, DC, where he founded a chain of cafeterias. He lived to be 101 years old. (Courtesy of Joel J. Wiest.)

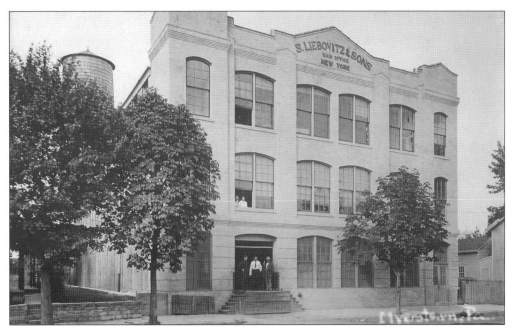

The S. Liebovitz & Sons shirt factory on East Main Street was a branch of a firm started in New York City around 1880. The factory seen here was built in 1905. Sometime after 1909, it was considerably expanded in size. Sometime after 1950, the Liebovitz family changed the company's name to Publix Shirt Corp. The firm closed down sometime after 1970.

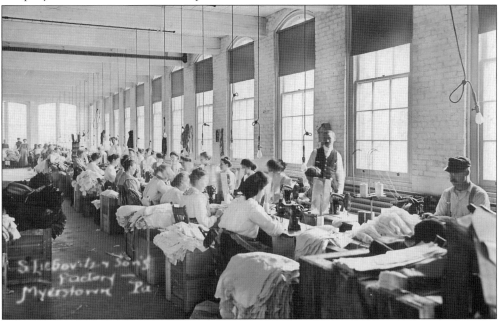

Shown here are dozens of Liebovitz plant workers, mostly women, sewing away prior to World War I. Another postcard at the Institute of American Deltiology proves that men also sewed shirts here. By the 1920s, sewing plants in three other eastern Lebanon County towns—Newmanstown, Richland, and Schaefferstown—had connections to the Myerstown plant. Hundreds of Myerstown residents have various memories of working here.

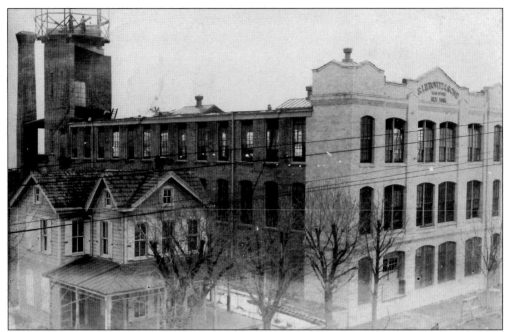

This 1909 view of the Liebovitz garment factory also shows a private home, which was replaced by an office building by the 1930s. Tessie Ranaldi Ondrusek mentions that her family lived in the home during the 1920s. The Liebovitz factory is the former site of the Myerstown Academy, a school established in 1840 that operated until the later 1860s. (Courtesy of Terry O. Schott.)

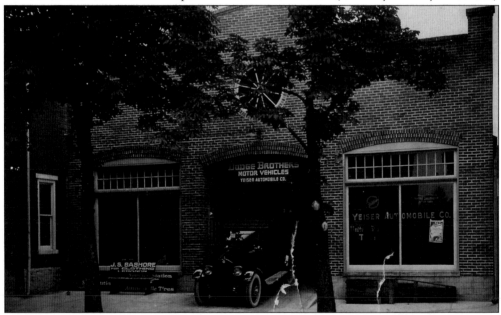

Yeiser Automobile Co., 19–21 West Main Street, had been selling Dodge "motor machines" for several years by the time this early 1930s photograph was taken. Warren Yeiser had established the business in the 1920s. Reppert's Appliances store was located here by the mid-20th century. On Fire, a Christian youth organization, is located here today. A gymnasium was built onto the rear of the building around 2007.

Standing outside of his store at 217 South Railroad Street in 1909 is Harry E. Stoner and his wife, Emma. Harry Stoner was a great-great-grandson of Isaac Meier through his mother, Susan Meier Stoner, and her father and grandfather, both named John. A century ago, nearly a dozen grocery and notions stores like Stoner's were operating in Myerstown's neighborhoods and vicinity. By the 1930s, Samuel Seibert, followed by his son George, was proprietor of this store.

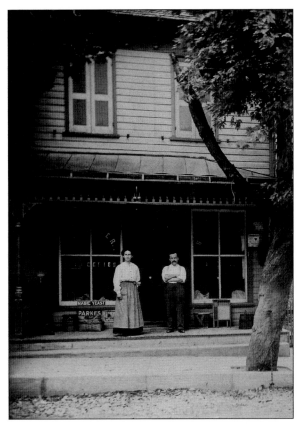

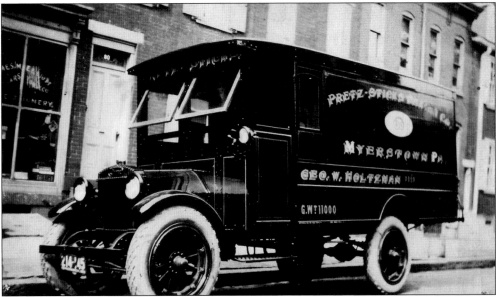

George W. Holtzman invented a machine to produce pretz-sticks (straight pretzels) in 1912 and, by the 1920s and 1930s, the item became known widely throughout the eastern United States and Canada. The company made all kinds of pretzel products until 1941. Here is a Pretz-Sticks Baking Co. delivery truck in the mid-1920s. (Courtesy of Jack L. Kiscadden Jr.)

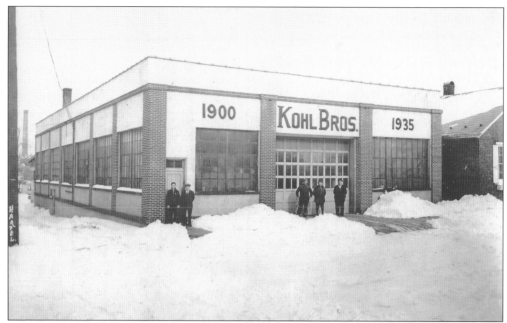

Inspired by an exhibit at the Centennial Exposition, Ezra Kohl purchased the first well-drilling machine in Lebanon County in 1881. In 1900, he organized a firm with his sons Harry (second from left) and Ervin (second from right), who took over as Kohl Bros. Inc., in 1912. By 1935, they opened this building on Muth Avenue. Kohl Bros. was awarded the contract to drill all wells and install all pumps along the original Pennsylvania Turnpike. (Courtesy of Nancy Kohl Gettle.)

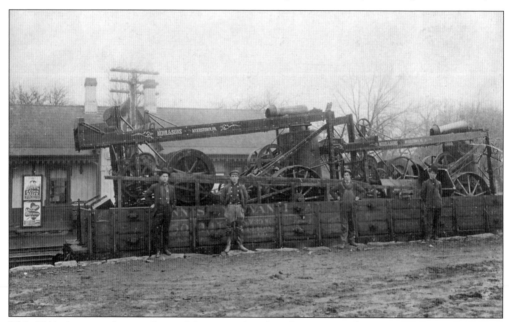

This 1911 photograph was taken at Myerstown's railroad station. At that time, Kohl Bros. used the railroads to transport their heavy well-drilling rigs. Harry Kohl is standing at the left; Ervin, his brother, may be next to him. By 1925, Kohl Bros. had the first four-cylinder, gas-mounted engine and Pennsylvania's first well-drill rigs mounted on trucks. (Courtesy of Jack L. Kiscadden Jr.)

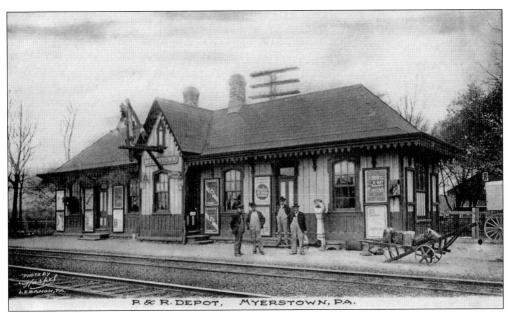

Myerstown's Philadelphia & Reading Railroad station was built in 1857, soon after the railroad was laid through the Lebanon Valley. Passenger service was discontinued on June 30, 1963, exactly 106 years to the day that it began. The station's chocolate and ivory colors seemed especially appropriate on Myerstown's Hershey Picnic Day (held on the second Tuesday in August from 1909 to 1970). Each evening at 9:14 p.m., when the "Queen of the Valley" came through, citizens set their clocks by its whistle.

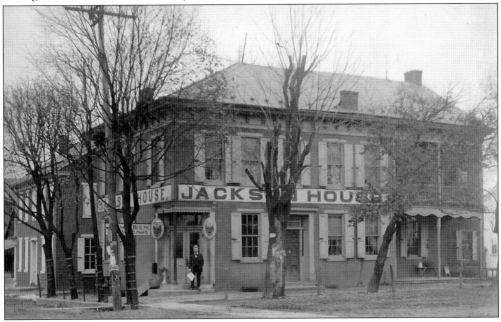

Jackson House, on the northeast corner of Railroad Street at the railroad, was a hotel until the early 1930s. This postcard, mailed in 1913, shows Milton G. Mensch, the proprietor, standing in the doorway underneath Deppen's Beer signs. Built at least by 1875, when William Fessler was proprietor, this structure is today an apartment building.

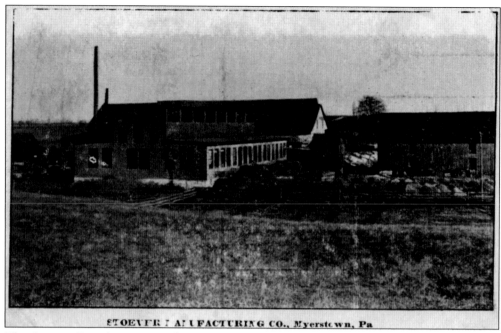

STOEVER MANUFACTURING CO., Myerstown, Pa

The Stoever Foundry & Manufacturing Co., at South Cherry Street and Stoever Avenue, was built about 1890 by Edward Karsnitz on land owned by Rosanna Stoever. Renamed the Myerstown Foundry & Manufacturing Co. by the 1920s, the firm made castings up to 10 tons in weight and manufactured pipe-threading machines. Leighton Krum Sr. was the president, and it became known as "Krum's Foundry." The company went out of business around 1938. By 1954, Quaker Alloy, a new castings firm, was in operation there.

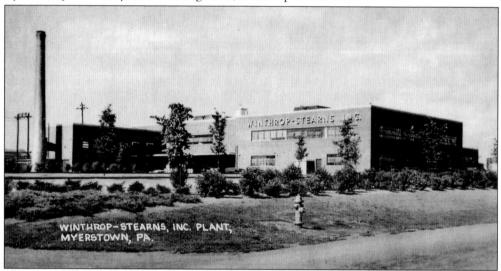

WINTHROP-STEARNS, INC. PLANT, MYERSTOWN, PA.

The Winthrop–Stearns plant went through several mergers and names, including Sterling Drug, until it was purchased by the original Bayer Corporation (of Germany) in the 1990s. Today, this plant, plus several newer buildings west along the railroad, form the sole manufacturing site for producing Bayer aspirin in North America. Many other well-known pharmaceuticals are manufactured at Bayer Corporation, Consumer Care. More than 500 people are employed here as of 2012.

Five

MYERSTOWN
ALBRIGHT, THE COLLEGE THAT ELOPED

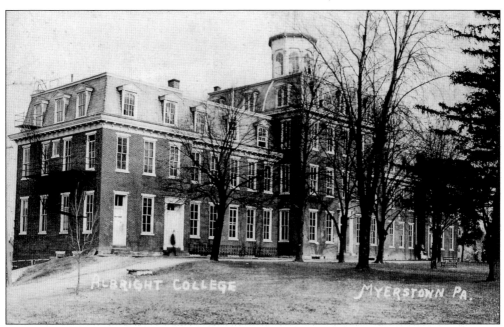

Albright College existed in Myerstown between January 3, 1895, and June 1, 1929. It began with a horse-and-wagon overnight exodus from a hilltop seminary (Schuylkill) in Fredericksburg, Lebanon County, during the Christmas holidays in 1894 and ended with a motor caravan away from its Myerstown campus to Reading, Pennsylvania, in June 1929. Seen here is Albright's main building in 1919.

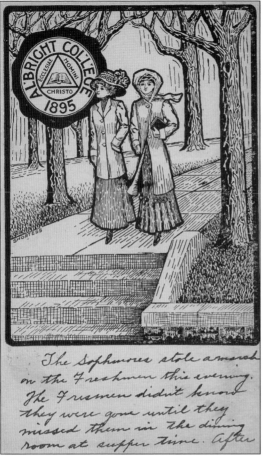

The Sophomores stole a march
on the Freshmen this evening.
The Freshmen didn't know
they were gone until they
missed them in the dining
room at supper time. After

Here is an artist's rendition of the Albright College seal on a postcard mailed in 1919. On the postcard, a student mentions a trick played on the freshmen by the sophomores. Albright was always coeducational. It was named during its Myerstown years, but it traces its founding to an 1856 educational institution called Union Seminary in New Berlin, Union County, Pennsylvania. Union had been established by the Evangelical Association, a Protestant denomination, the founder of which had been Jacob Albright.

Pictured below is Albright's main building in 1909. Administration, classrooms, and the men's dormitory were housed here.

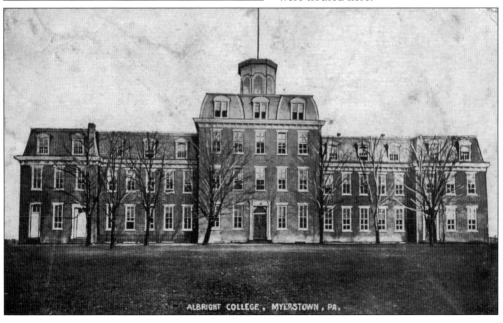

ALBRIGHT COLLEGE, MYERSTOWN, PA.

First called the Ladies Building, this structure was later named for Jeremiah Mohn, treasurer of Albright College. Mohn purchased the building in 1905 as a women's dormitory for the college. It had been erected in 1870 for Jacob Baney, a prominent horse dealer with farms around Myerstown and a sales stable in Philadelphia. Baney's Myerstown stables were located where the graystone school now stands. Financial difficulties caused him to sell the mansion in 1896.

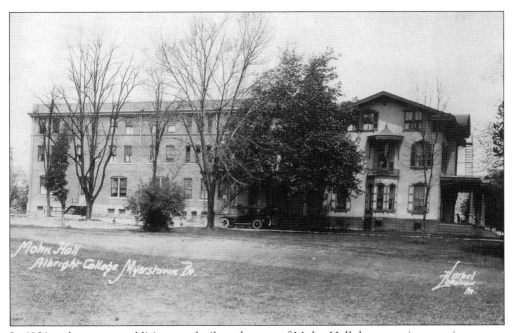

In 1921, a three-story addition was built at the rear of Mohn Hall due to an increase in women students from out of town.

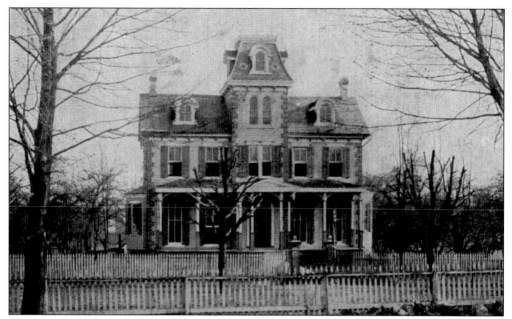

South Hall was located on Park Avenue west of College Street and had been the home of B.J. Smoyer until 1903 when it was purchased for Albright's biology laboratory and renamed Bower Memorial Hall. However, it was destroyed by fire a few days before Christmas in 1914. The laboratories were moved to a new building next door, at Park and College Streets, still in use today as the national offices of the Evangelical Congregational Church.

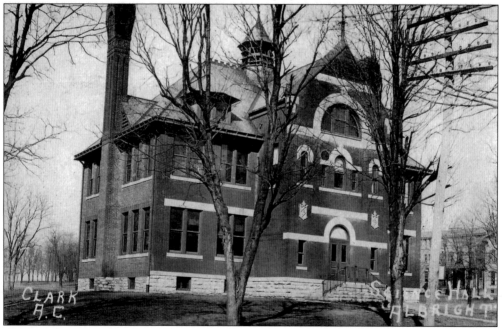

This structure was Myerstown's high school between 1895 and 1915 but was Albright College's Science Hall by the time of this mid-1920s postcard. In 1936, when Myerstown organized a community library, it was located here. In 1954, the Evangelical Congregational Church remodeled the building for an infirmary. In the fall of 2011, this building was demolished.

Here is a 1926 view from College Street of Albright College's main building, showing the north wing that had been constructed in 1921–1922 to provide a new dining room, colonial chapel, auditorium, and a third-floor dormitory for men.

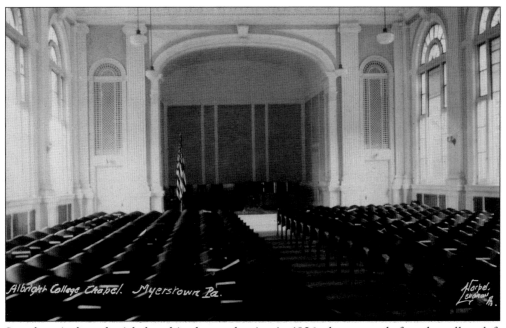

Seen here is the colonial chapel in the north wing in 1926, three years before the college left Myerstown for Reading. The chapel, designed with a stage, could be used as an auditorium for plays and concerts. It is named in memory of Rev. Walter J. Dech, who had come to Myerstown in 1898 as an Albright professor and chose to remain here as pastor of Zion Evangelical Congregational Church.

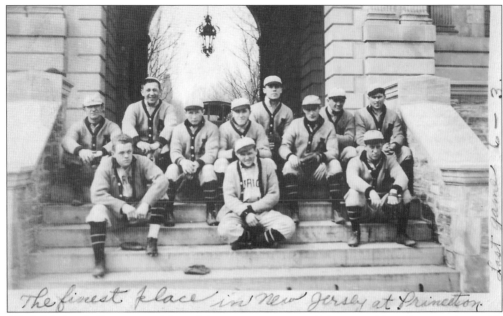

The finest place in New Jersey at Princeton.

Albright's baseball team participated in a tournament at Princeton, New Jersey, where this photograph was taken in May 1909. Coach Charles S. "Pop" Kelchner sent this card to Elam Zug of Mastersonville, Pennsylvania, with the message: "We have won 6 games and lost 4 thus far and don't expect to lose anymore." Albright College's yearbooks contain names of the players. (Courtesy of Jack L. Kiscadden Jr.)

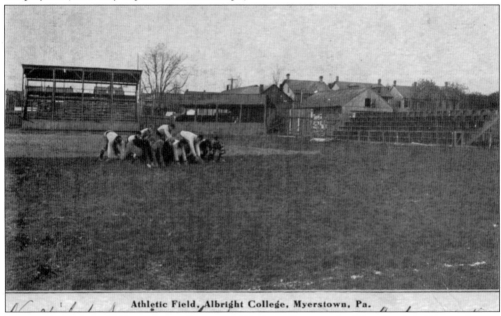

Athletic Field, Albright College, Myerstown, Pa.

The Albright College football team is seen here practicing in 1906. The school had a field and bleachers but no gymnasium until 1907. The bleachers had been given to the college by Charles "Pop" Kelchner when he returned as athletic coach in 1905. He had been the very first graduate of Albright College in 1895. A man of many talents, Professor Kelchner also taught French and history at the college.

Charles "Pop" Kelchner was coach of Albright's athletics in 1916 when they beat Temple University in Philadelphia. John Zinn was captain of the 1916 team. Over time, "Johnny" Zinn became a sports legend in Myerstown, and "Pop" Kelchner became a national sports legend. As a scout for the St. Louis Cardinals, Kelchner discovered Stan Musial in the late 1930s. Since 1956, Albright College teams play baseball on Kelchner Field in Reading.

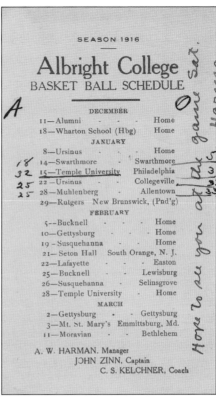

Seen here is a baseball game held on Albright's Myerstown diamond around 1914. The school's main building can be seen in the distance on the college hill. (Courtesy of Nancy Gambler.)

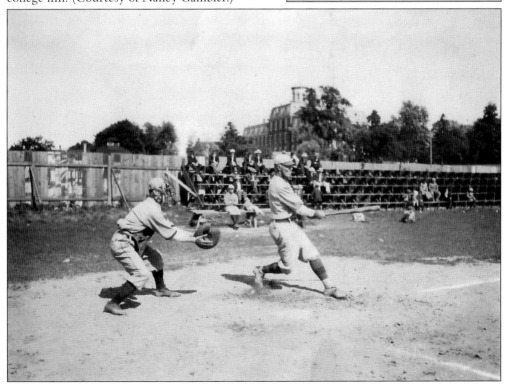

The west wing of Albright's main building is seen on a snowy day. When that wing was dedicated, on December 23, 1875, George F. Baer of Reading gave an address significant for recognizing the contributions of Pennsylvania Germans to American history. Palatinate College had been founded in 1867–1868 but experienced financial difficulties by the 1890s. Faculty and students from Schuylkill Seminary at Fredericksburg took possession of Palatinate's campus in January 1895 and founded Albright.

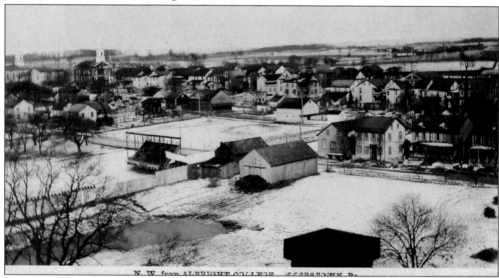

Daniel Holtzman produced this postcard in 1909. The view is to the northwest from the cupola on the college hall. The two churches—Lutheran and Reformed—on the hill at West Main and Locust Streets can be seen. Between the churches is John Bowman's Mercantile Store. Carpenter Street runs through the center of the photograph. The handwritten message on the back reads: "Kind Friend. Am sorry but I would rather not have you call on Sat. Eve for various reasons. Yours, E.C.L." (Courtesy of Terry O. Schott.)

Daniel Holtzman pointed his camera due north from Albright's cupola for this view. He captured the rear of the Coover House (center) and the rear of Zion United Evangelical Church (right), as well as backyards and small barns along South College Street (foreground). (Courtesy of Terry O. Schott.)

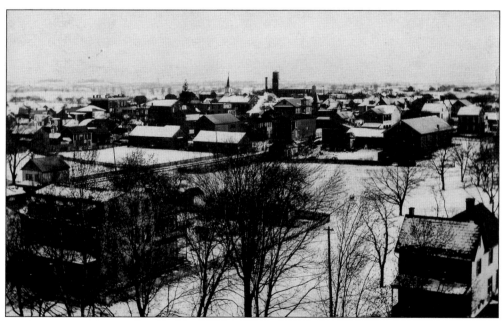

For this winter 1909 view of Myerstown from the cupola at Albright, Daniel Holtzman pointed his camera northeast toward the Liebovitz garment factory (center). To its left are the steeple of Zion United Brethren Church and the fourth floor of the Bahney House. The Keystone Hook & Ladder house is visible and, to its right, Jacob Baney's horse stables, where the high school would be built in 1914–1915. (Courtesy of Terry O. Schott.)

Seen here in 1926 is the new dining room in the north wing of Albright's main building. Since 1953, the former Albright campus has been the site of Evangelical Theological Seminary, and the former dining room is now the seminary's Clifford Zinn Memorial Conference Room. (Courtesy of Nancy Gambler.)

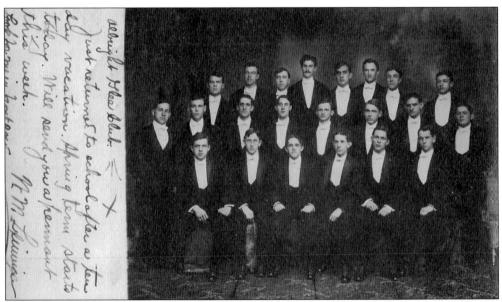

Postmarked in April 1908, W.M. Leininger sent this card of the Albright Glee Club to Emily Schall at Irving College in Mechanicsburg, Pennsylvania, and told her to look for him in the front row. (Courtesy of Terry O. Schott.)

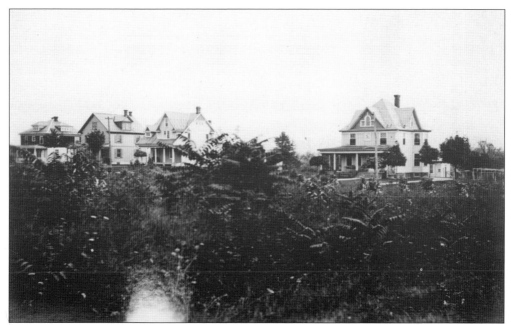

This 1919 photograph shows the West Park Avenue houses of four Albright College professors above a field of cornstalk fodder. The area was called Faculty Heights. From left to right are the homes of Aaron Gobble (Latin and Hebrew), Walter Dech (Greek and German), Harry Kiess (mathematics), and Charles Kelchner (French, history, and athletics). The Kiess home was owned by Mayor Rodney P. Steltz and his family by the time of Myerstown's bicentennial (1968). (Courtesy of Jack L. Kiscadden Jr.)

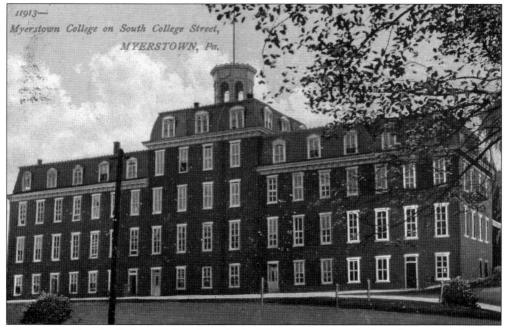

The north side of Albright College's main building is seen here before the north wing was attached in 1921–1922. The school is identified as Myerstown College on this card.

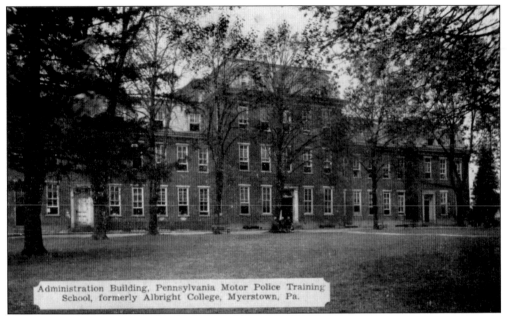

Administration Building, Pennsylvania Motor Police Training School, formerly Albright College, Myerstown, Pa.

The Pennsylvania State Police came to Myerstown in 1938 and trained on the former Albright campus for several years before relocating to Hershey. On a 1939 postcard (not pictured here), they are seen drilling on the east campus by Mohn Hall. At that time, they were called motor police and they trained on motorcycles. This postcard explains itself.

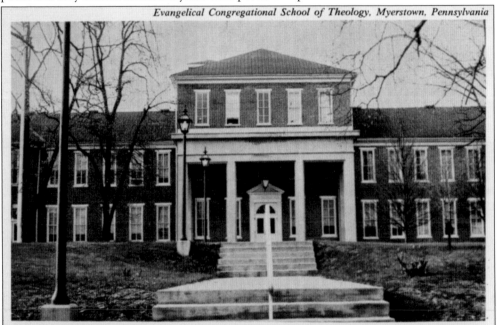

Evangelical Congregational School of Theology, Myerstown, Pennsylvania

The former Palatinate-Albright main building, seen here on a 1971 postcard, sans cupola, was remodeled for the Evangelical School of Theology by 1953. The college hill is now crowned with a tree-shaded campus and a modern theological library and married-student housing by the hill to its west. In 2010, the institution was renamed the Evangelical Theological Seminary of the Evangelical Congregational Church.

Six

JACKSON TOWNSHIP
THE TOWNSHIP BEAUTIFUL

Jackson Township was formed from the northern part of Heidelberg Township late in 1820, thus becoming the seventh township in the new county and the first formed out of the original six that existed when Lebanon County was created on February 16, 1813. When Daniel Holtzman took this photograph in 1908 from a nearby church spire, all of this land, including Old Union Cemetery, was in Jackson Township.

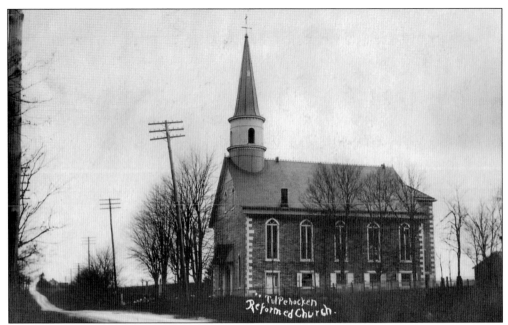

Tulpehocken Reformed Church is the oldest religious congregation in Lebanon County. John Philip Boehm, the "father" of the German Reformed Church in America, conducted communion services for members on October 18, 1727. Landowner Casper Wister of Germantown conveyed deed to the congregation in exchange for 40 pounds and an annual payment in perpetuity of a red rose in the month of June to him and his heirs. The structure seen here in 1906 is the third and current one, built in 1853.

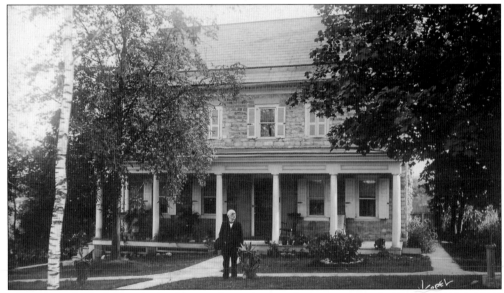

A longtime pastor of Tulpehocken Reformed Church, Rev. Henry J. Welker (1884–1921) stands in front of the parsonage. By 1813, a quarry developed on church land became a source of income for the congregation. Rev. Dr. H. William Stoy was pastor from 1752 to 1755, before he practiced medicine. Stone from the quarry was used to construct his house and office in Lebanon; in the 1970s, the house became home to the Lebanon County Historical Society.

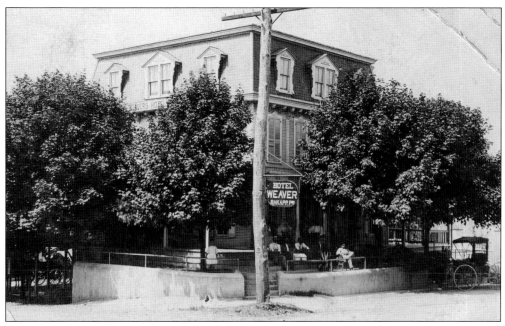

Weaver's Hotel, Millardsville, was located two miles east of Myerstown on the former Berks and Dauphin Turnpike. It was built by William Weaver prior to 1900. This postcard shows the hotel in 1911, when R.H. Kapp was the proprietor. Known also for decades as the Millardsville Hotel, it became the Danish Inn, owned by Kai Skov, in the 1970s. In the present century, The Porch, a fine restaurant operated by Joe Edwards, is located here. (Courtesy of Leonard H. Schott.)

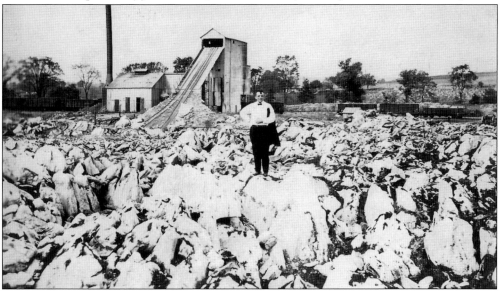

He did not identify himself, but the gentleman standing on stones identified the quarry as the one at Millardsville, two miles east of Myerstown. Limestone from this quarry has been used in dozens of structures throughout eastern Lebanon County. J.B. Millard's Lime & Stone Company operated the quarry when it flooded overnight around 1930 due to an overactive spring. Currently operating here is Willow Springs Park, a scuba-diving training site that sponsors a popular polar bear plunge every New Year's. (Courtesy of Jack L. Kiscadden Jr.)

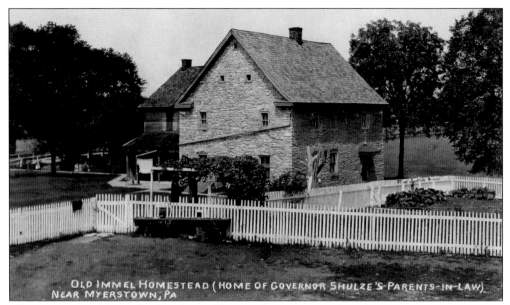

The Johannes and Anna Barbara Immel house, along Ramona Road west of West Myerstown, has the year 1759 on its date stone. The limestone house, with steep-pitched roof and arches above each window, reflects old-world Germanic architecture. Gov. John Andrew Melchior Schulze married Susan Immel, granddaughter of Johannes Immel (daughter of Leonard Immel), meaning that a future first lady of Pennsylvania (1823–1829) grew up here.

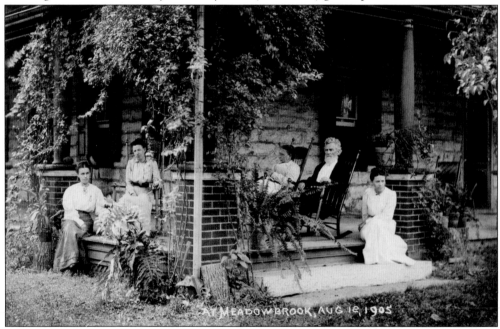

This photograph of Meadowbrook, the farm home of the Henry Mosser family, north of Myerstown, shows the family sitting outside on their porch in the summer of 1905. Reverend and Mrs. Mosser are sitting on rockers and, from left to right, are daughters Lizzie, Rachel (sitting on chair), and Dora (sitting on steps). Rachel Mosser taught art in Myerstown-area schools for many years through the late 1930s. (Courtesy of Myerstown Community Library.)

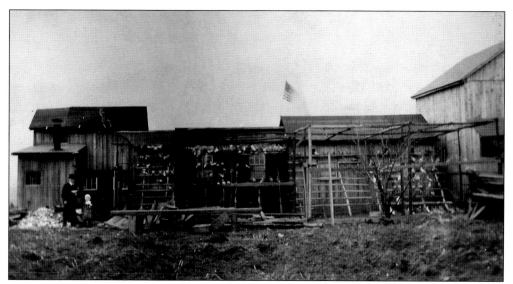

Seen here are the squab pigeon houses of Charles H. Seibert, Rural Delivery Route No. 2 in Myerstown, in 1909. High-grade squab meat was an important part of America's food industry until the first quarter of the 20th century. Seibert closed down his pigeon business in January 1929. Excessive hunting and changes in Americans' taste led to the decline, but not demise, of the domesticated squab industry. The modern squab industry uses utility pigeons. (Courtesy of Jack L. Kiscadden Jr.)

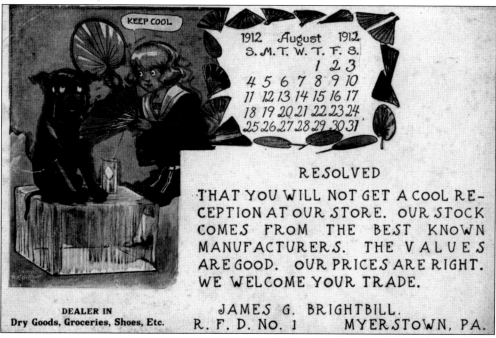

KEEP COOL

1912 August 1912
S. M. T. W. T. F. S.
 1 2 3
4 5 6 7 8 9 10
11 12 13 14 15 16 17
18 19 20 21 22 23 24
25 26 27 28 29 30 31

RESOLVED

THAT YOU WILL NOT GET A COOL RE-
CEPTION AT OUR STORE. OUR STOCK
COMES FROM THE BEST KNOWN
MANUFACTURERS. THE VALUES
ARE GOOD. OUR PRICES ARE RIGHT.
WE WELCOME YOUR TRADE.

DEALER IN
Dry Goods, Groceries, Shoes, Etc.

JAMES G. BRIGHTBILL.
R. F. D. NO. 1 MYERSTOWN, PA.

Brightbill's General Store, at a crossroads two miles north of Myerstown, was well known in northern Jackson Township in the first half of the 20th century. Monthly calendar postcards mailed to customers were popular a century ago. Banks, automobile dealerships, and stores of all kinds—clothing, furniture, hardware—used postcards to advertise. James Brightbill's store sold everything from molasses to shoes and was a center of local news.

The home and shop of William Leinbach, known as "The Itinerant Weaver," is visible on this postcard produced in the 1990s. Well-known for weaving coverlets using the colonial overshot method, Leinbach is located in the tiny village of Royertown. Lebanon County's pioneer Church of the Brethren—Royer's Meeting House—was built in Royertown in 1840, when the Brethren were known as the German Baptists. Note the church, now Mennonite, in the distance.

Fairview Mennonite Church, on Elco Drive near Miller Road, was built in 1943 on the site of a farmstead known to have been the first Amish settlement in Lebanon County. An ancient headstone along the road states that Christian and Anna Beiler occupied a 175-acre tract here from 1777 until 1803, and that in a corner of the field is the family burial plot containing five graves. In 1803, the Beiler family left the area for Lancaster County.

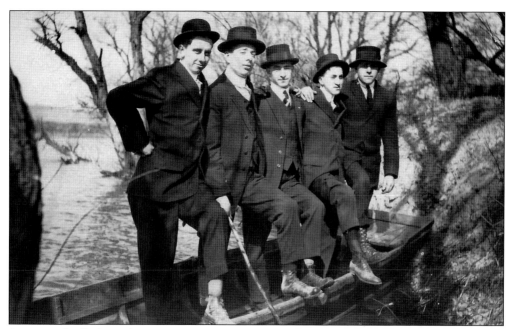

A group of well-dressed Myerstown-area gentlemen enjoy a Sunday afternoon outing at Strack's Dam in October 1922, apparently confident that they will not rock the rowboat. They are, from left to right, Henry Albert, Clafflin Bowman, Ray Phillips Sr., Harry Spangler, and Ray Hutchinson. Strack's Dam, northwest of Myerstown, was known as a habitat for bog turtles, a species in danger of extinction in the 21st century. (Courtesy of Jack L. Kiscadden Jr.)

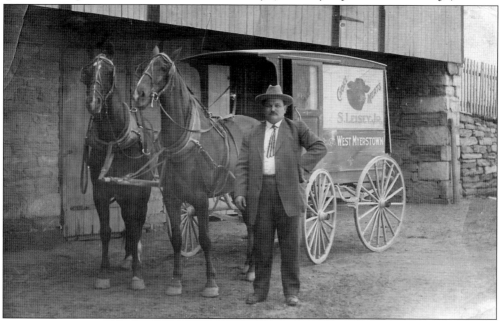

West Myerstown was known for its butchers and horse-drawn butcher wagons, which traveled the streets of Lebanon and Myerstown in the years prior to World War II. Sam Heisey Jr. posed in 1914 with his two-horse wagon at the barn on the northeast corner of West Main and Fairlane Avenues.

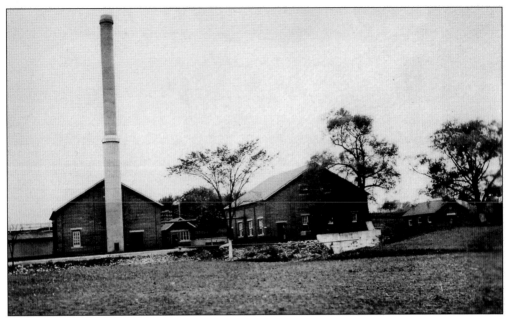

Shown on this 1918 postcard is the Ramona pumping station, built by the Ohio Oil Company about 1900 when oil came into demand as a fuel. The remains of Lock No. 7 on the Union Canal, which ceased operating by 1885, are visible. Located along Fairlane Avenue one-half mile south of West Myerstown, these buildings became the location for Clarence W. Whitmoyer's poultry pharmaceutical laboratories in the 1930s. (Courtesy of Jack L. Kiscadden Jr.)

This was Spangler's School, one of eight one-room country schoolhouses in Jackson Township that operated until 1958, when a consolidated school opened in West Myerstown across from the two-story school (now a residence). Spangler's School still stands as a home one mile south of Myerstown along Route 501.

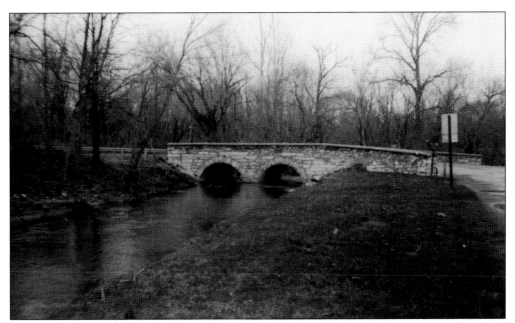

Here is the double-arched limestone bridge across the Tulpehocken Creek at the east end of Mill Street where Quarry Road begins. A short distance to the south stands an abandoned mill that became well known for its homemade ice cream (Holtzman's) in the mid-20th century.

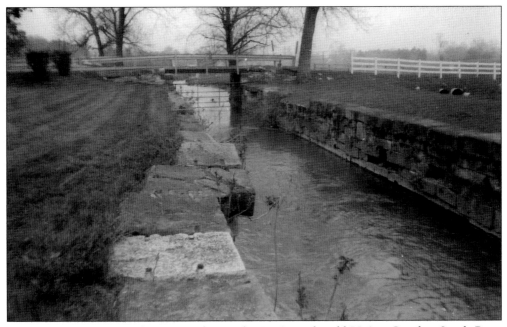

On this 1990s photographic postcard is Lock No. 8 on the old Union Canal at South Race Street, across from the Bassler Homestead of 1799 (better known today as the Wenger family property). One can see that the locks were not wide enough to survive competition from New York State's Erie Canal, which had opened in 1825 and had spurred completion of the Union Canal. Operations on the Union Canal ceased by 1885.

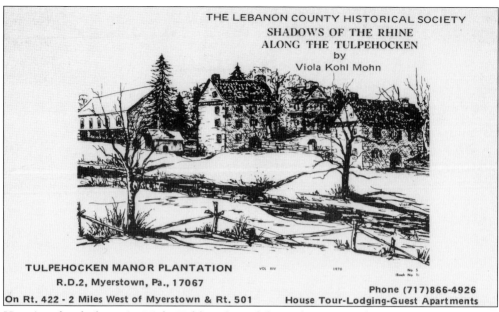

THE LEBANON COUNTY HISTORICAL SOCIETY
SHADOWS OF THE RHINE
ALONG THE TULPEHOCKEN
by
Viola Kohl Mohn

TULPEHOCKEN MANOR PLANTATION
R.D.2, Myerstown, Pa., 17067

VOL XIV 1970 No 5
Book No 1:

Phone (717)866-4926

On Rt. 422 - 2 Miles West of Myerstown & Rt. 501 House Tour-Lodging-Guest Apartments

Here is a sketch, by artist Viola Kohl Mohn, of the 18th-century plantation at Tulpehocken Manor about the time that Michael Ley was serving in Washington's Continental Army. His father, Christopher Lei (Ley), had purchased the property in 1732 and built several unique limestone structures. The third, larger house was built in 1769 by Michael, who entertained George Washington there in 1777 and again when Washington was president in the 1790s.

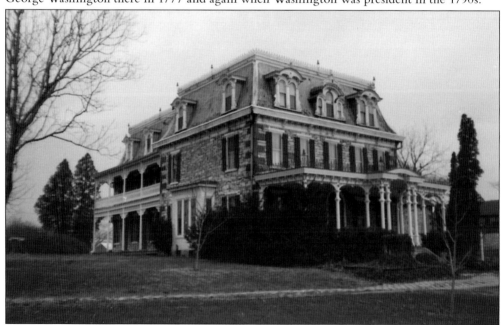

The eight-room Germanic limestone house of 1769 built by Michael Ley was transformed into this 27-room Victorian manor house between 1883 and 1885 by the Samuel Urich family. In recent decades a guesthouse, it is again in private ownership. President Washington's second visit in 1793 to his friend provided an opportunity to inspect the new nation's first canal locks, along the nearby Tulpehocken Creek.

This is the John F. McLaughlin home, located toward the west end of West Myerstown on the north side of the street. His carriage-making and repair shop can be seen on the left of this postcard from around 1911–1914. Houses like this, with a variety of porch post designs and multiple bays, could be seen in even the smallest towns. Although the water pump at the front is gone, this residence is very recognizable today.

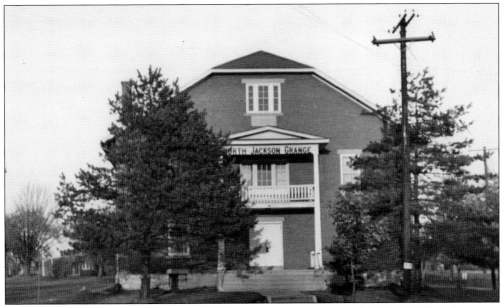

The North Jackson Grange was built by members between 1921 and 1924 at Walborn's corner, two miles north of Myerstown. It is one of three remaining farmers granges (Patrons of Husbandry) in Lebanon County (the others are Bunker Hill and Kimmerling's).

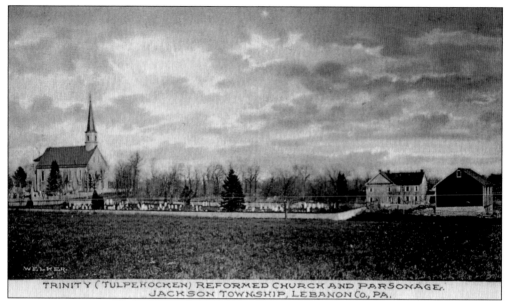

Trinity Tulpehocken Reformed Church today is a congregation of the United Church of Christ. The church and its parsonage are seen here in 1905 with the old cemetery between them. Isaac Meier, founder of Myerstown, lies buried there, along with other Germanic and Huguenot pioneers who migrated to this region in colonial times from the Schoharie Valley of New York State and through the Port of Philadelphia.

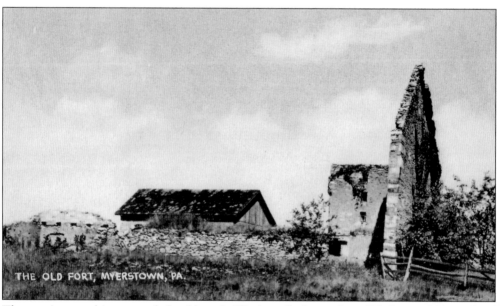

The caption on this postcard should read, "Ruins of a barn along PA Route 501 south of Myerstown on the original Jacob Spangler farm, built 1782." In 1947, an out-of-state photographer confused this with Isaac Meier's house, which at that time was referred to as "the old fort." This postcard is a sad reminder that many of eastern Lebanon County's sturdy limestone barns have fallen victim to fire or neglect.

Seven

RICHLAND

THE BOROUGH BEAUTIFUL

Jacob S. Mohler's Stone Crusher Richland Pa

Richland was incorporated as a borough in September 1906 with land taken from Jackson and Millcreek Townships. Almost double the extent of Myerstown's borough limits, Richland took in many farms, such as Jacob Mohler's. This property was more recently owned by the Titus Nolt family. One reason Richland folks call their town "The Borough Beautiful" is because of its setting amid rural farmsteads. (Courtesy of Jack L. Kiscadden Jr.)

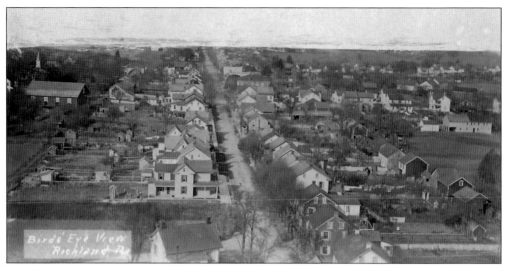

A 1915 bird's-eye view of Richland, looking westward along Main Street from the Richland Water Company standpipe, reveals a sense of order and neat houses along the main thoroughfare.

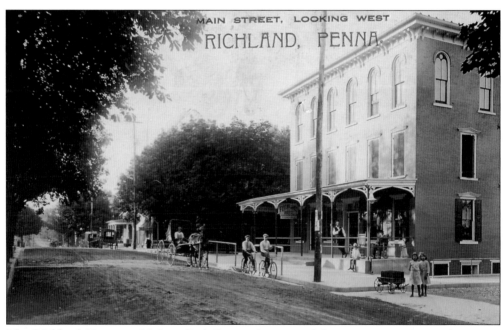

MAIN STREET, LOOKING WEST
RICHLAND, PENNA.

The Richland House on Main at Park Streets, just east of the town center, is seen here on a day in 1914. Originally called the Highland Hotel in the 19th century, the Richland House came to be owned by George Eckert in 1923 and was referred to as "Eckert's hotel" until 1967, when it was demolished for a parking lot by one of the successor banks to the Richland National Bank.

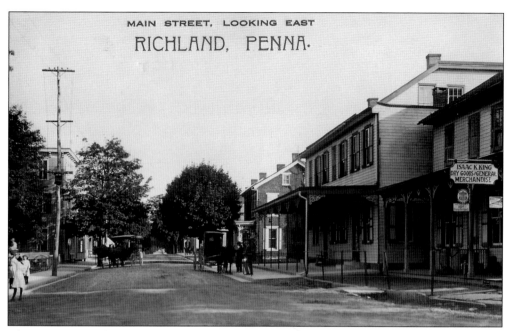

This 1914 view of Richland's Main Street is looking east from Race Street and the railroad. Isaac King's general store on the right had been his father-in-law's, Samuel Geib's, a few years earlier. Built in 1863, it had been operated by Edward Landis. Beyond the store is the Union House. The message on this postcard reads, "Come for the red beets. They are ready."

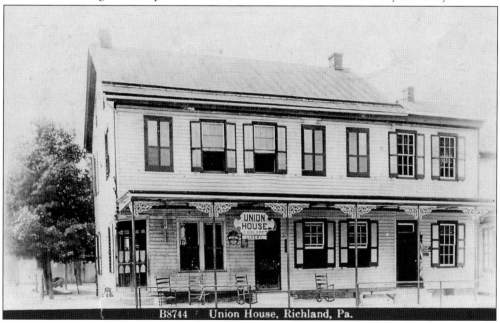

Here is a closer view of the Union House, a hotel and livery since 1871. The first election for borough officers was held on February 25, 1907, and it was at the Union House that those officers met and got organized. Council members included W.J. Klopp, M.R. Landis, Edward Smaltz, Elias Brubaker, and D.K. Weigley. M.E. Holstein was the burgess, and H.G. Wiest was the president of council. Today, the building houses the End Zone Inn.

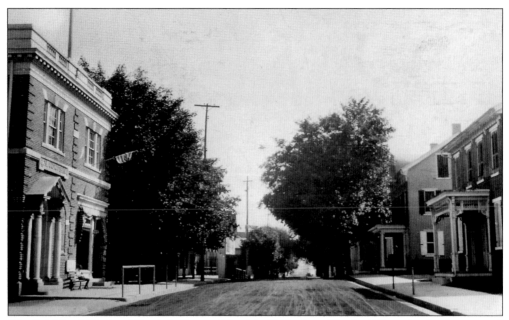

The Richland National Bank is featured in this 1910 view. The buildings in the foreground on both sides of east Main Street served as the bank's location in the new borough. Richland National opened its doors for business on September 18, 1906, one day after Richland became a borough, in the Elmira Shirk house (right). By 1909, the building on the left had been completed for the bank. Vincent Achey is the new owner.

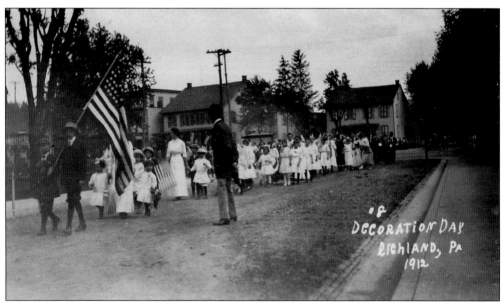

Decoration Day, the former name of Memorial Day, always fell on May 30 before World War I. The towns of eastern Lebanon County had parades that led to local cemeteries for patriotic exercises and speeches. Here is a view of Richland's parade in 1912. Oscar Sellers, Richland's full-time barber and spare-time photographer, produced a long series of cards of the 1912 event.

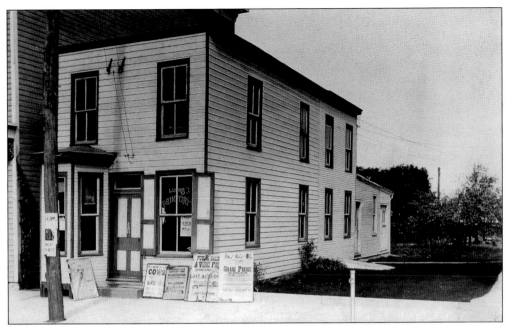

The Print Shop of M.R. Landis is seen in this postcard, mailed in 1913. Later, he sold out to Snook and Levengood, also printers. Following Snook's death, Levengood operated a stationery store here. By the 1970s, this building had been remodeled and was operating as the Snack Bar. By the time of the borough's bicentennial in 2006, it was called The Richland Pantry.

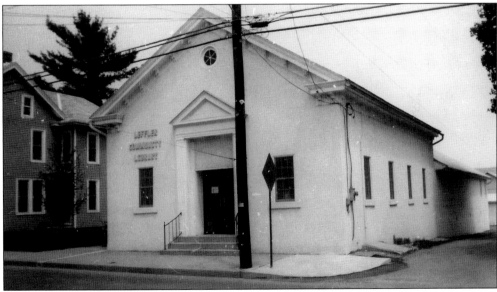

The Richland Community Library, 111 East Main Street, is called Leffler Community Library in this 1990s photograph. The library and the building have a long history, dating back to 1868, when Allen Bollinger built this structure for the Richland Town Band. Richland had created a library as early as 1886 in the grammar school. By 1967, when Richland's Community Library Association was organized, this building was purchased. A rear addition was built in 1990. (Courtesy of Lebanon County Historical Society.)

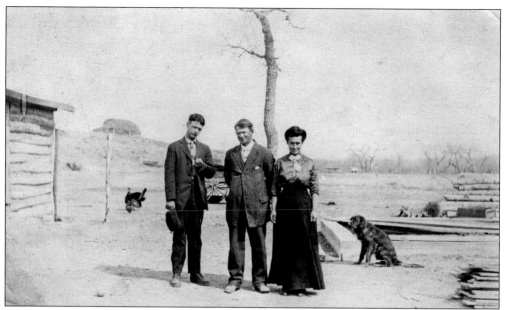

M.H. Leitner of Richland went west with his family about 1900. The message on this 1907 postcard reads: "Dear Brother and family. Here is a picture of my family. Vale is getting rather big for a 13 year old boy. This is a pretty good picture of my wife. The dog, turkey and I did not take so well. Best wishes to all. M.H. Leitner." (Courtesy of Lebanon County Historical Society.)

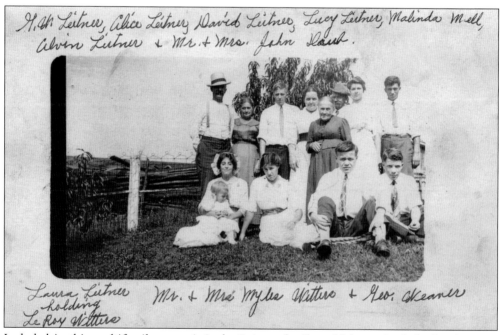

Included in this multifamily portrait is the Leitner family, which received the handwritten message from a brother in the west. This photograph, taken around 1910 near Richland, includes related Daub, Mell, and Witter families. The decades on either side of 1900 were years of growing interest in and organization of family reunions in the eastern United States. (Courtesy of Lebanon County Historical Society.)

Here is the Neptune Fire Company's new fire hall, built in 1922 on East Main Street on former Yingst property. A movie theater was built into the hall, where moving pictures were shown from April 1923 until 1969. The arrival of television caused a sharp decline in attendance. In 1971, the fire hall was expanded to the east with the addition of a two-bay engine room on Mishok property. (Courtesy of Nancy Gambler.)

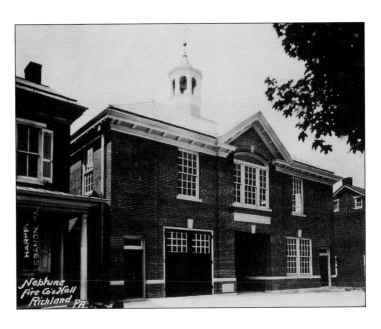

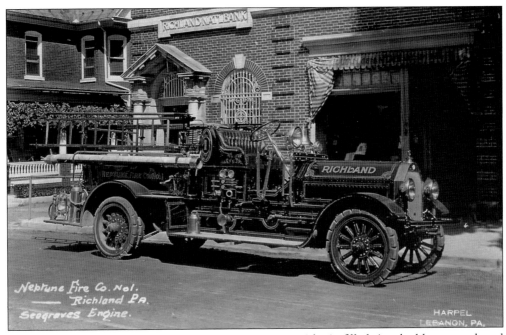

The Neptune Fire Company's new Seagraves Engine with air-filled tires had been purchased in 1921 for $11,750. It is displayed proudly in front of the Richland National Bank in 1921, before the new fire hall was built. The old fire hall was located at 19 North Park Street, near the John Zug Feed Mill. Occupying part of the bank building at this time was a general store, Z.E. Killian's, formerly Jacob Mell's.

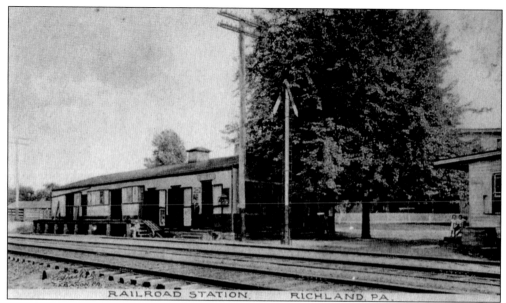

On a summer day in 1906, Lebanon photographer Luther Harpel took this photograph of the Philadelphia & Reading Railroad station at Richland. This depot stood east of where the railroad tracks diagonally crossed the intersection of Main and Race Streets.

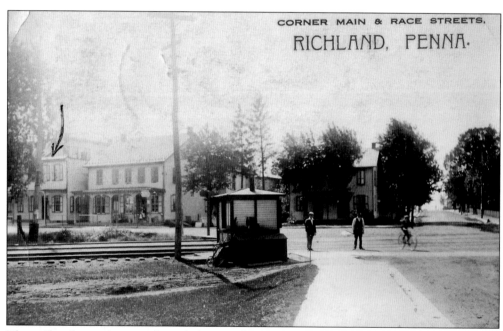

CORNER MAIN & RACE STREETS,
RICHLAND, PENNA·

The railroad crossing watchman's box is featured in this 1915 postcard. A well-known stationmaster in Richland for many years was Frank Landis, and a watchman of note was Philip Pfautz. Very likely, they are the two gentlemen posing here. To the left of the telephone pole can be seen I.B. King's Store and the Union House. The sender of this card pointed out his room in the Union House with an arrow.

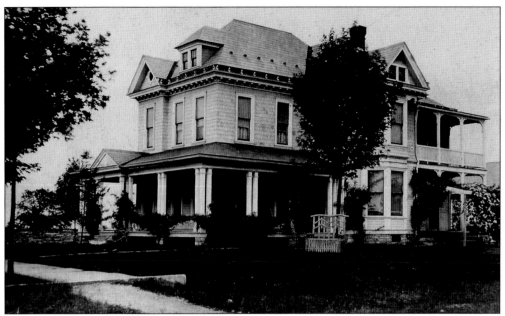

One reason that Richland prides itself as "The Borough Beautiful" is the many fine homes located throughout the community. In this c. 1908 postcard photograph, taken by Oscar A. Sellers, is the home of the Landis family. At midcentury, it was identified as the home of Effie Landis. Members of the Landis family have made contributions to the Richland community through the years, as well as to other eastern Lebanon County towns.

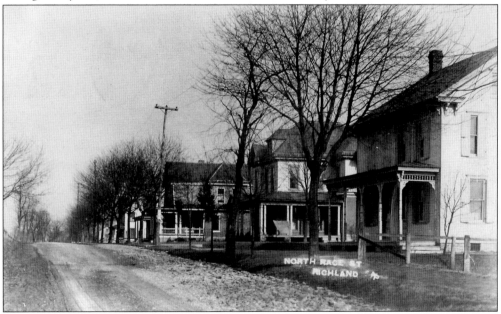

Postmarked in Richland on November 27, 1913, this postcard showing homes on North Race Street contains the message: "5 A.M. Forgot to stop at Noll's about washing machines. Will do so this morning. Ray wants chicken today, will kill a rooster since one of the young chickens lays now and one of the old ones is sick. Think it will be dead by this time." Reverend Waltz in Wayland, New York, received this card unsigned.

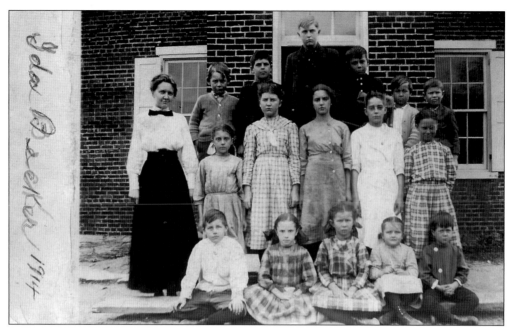

Ida Becker poses with her pupils outside of the Richland School in 1914. Shown here are, from left to right, (first row) Henry Donough, May Shanaman, Sarah Buffamoyer, Mary Marks, and Norman Wenger; (second row) Helen Shanaman, Annie Marks, Olive Shanaman, Laura Leitner, and Stella Miller; (third row) Becker, Edward Ernst, Isaac Marks, Robert Marks, Burlester Buffamoyer, Clarence Parsons, and J. Henry Marks. This group comprised nine elementary and junior high grades. Three students graduated at Richland High School's first commencement, in 1911. (Courtesy of Lebanon County Historical Society.)

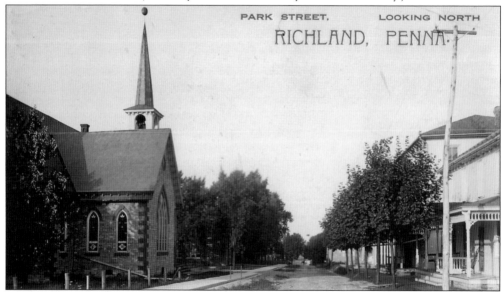

Shown here is Park Street, looking north from near its intersection with Church Street, in 1913. The Richland public school buildings are hidden by trees on the left. The graystone Grace Reformed Church is in the foreground. Across the street can be seen the three-story hall of the Patriotic Order, Sons of America, Camp No. 160.

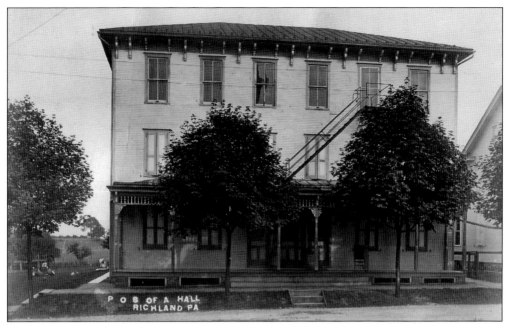

The Patriotic Order, Sons of America, Camp No. 160, organized in 1886, built this hall at Park and Church Streets in Richland about 1900. P.O.S. of A. meetings were held weekly, with strict rules, admitting only males over the age of 16. Patriotism, fraternity, and family insurance were its rationale for existence. P.O.S. of A. halls, like fire halls, usually became community social centers, especially in the small towns of America before World War I. (Courtesy of Nancy Gambler.)

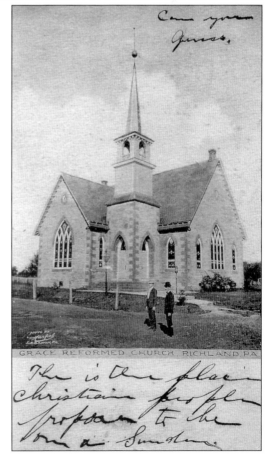

Grace Reformed Church, at South Park and Church Streets in Richland, was built in 1901. The stone for its construction was hauled from the quarry at Millardsville in Jackson Township. The congregation had existed since the 1870s and, previous to 1901, had met in the Richland Band Hall built by Allen Bollinger in 1868. Today, this is a congregation of the United Church of Christ (UCC). From 1934 until 1957, its name was Grace Evangelical and Reformed Church.

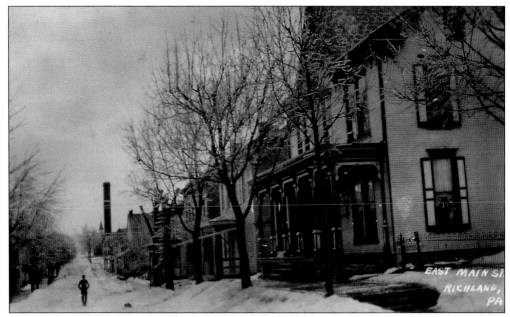

This east-facing view of Main Street shows the home and office of well-known physicians who served Richland residents a century ago. On the right is Dr. Levi Zimmerman's, and later Dr. John Boger's residence. In the distance is the water standpipe that had been erected in 1904. This street view, like others throughout this book, exhibits the late 19th–century vernacular architecture of the carpenter-builders in Pennsylvania German towns.

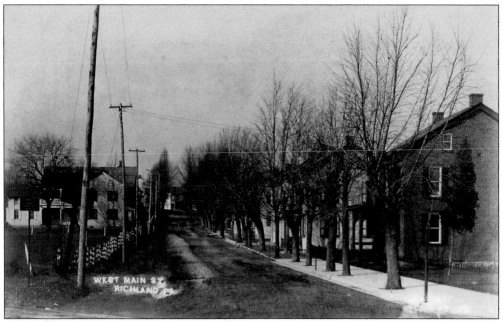

This postcard looks west on Main Street from its intersection with Race Street and where the railroad tracks cross it diagonally. Oscar A. Sellers produced this postcard in 1912 or 1913. Today, the Richland post office is located where there is vacant land on the left.

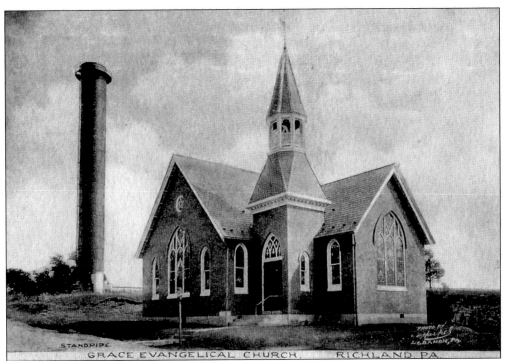

Grace United Evangelical Church, on East Main Street, was built in 1901. The denomination had established Albright College in Myerstown in 1895 and founded several local churches in eastern Lebanon County in the early 20th century. Today, this structure is the home of Faith Community Church. The Richland Water Company's standpipe, erected in 1904 near the church, had a walkway around the top that enticed antics by daring youth. Early on, the railing had to be removed.

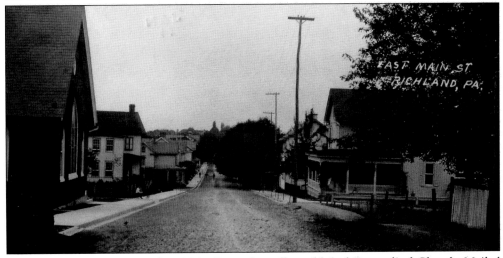

This view is to the west on East Main Street from Grace United Evangelical Church. Mailed in early 1911 to J.W. Waltz, a student at Princeton Seminary, this postcard's sender mentions several activities in the life of a Richlander, such as attending church services on a Sunday evening, washing in the morning, going out driving with "Mrs. Seibert," and buying "goods for 2 waists for myself to make them this afternoon."

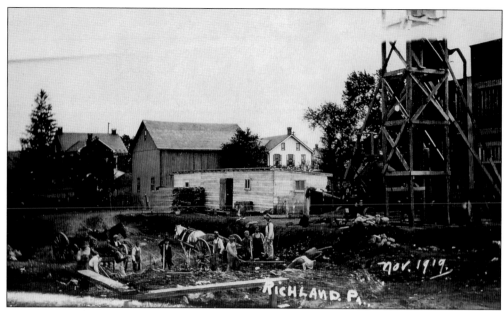

In November 1919, excavation for an addition to the Curtis & Jones Shoe Factory was under way. The main factory was built by 1917 and had prospered during the World War I years. By 1919, an addition was planned at the factory located between North Curtis Street and the railroad. Homes along South Race Street can be seen in the distance. (Courtesy of Lebanon County Historical Society.)

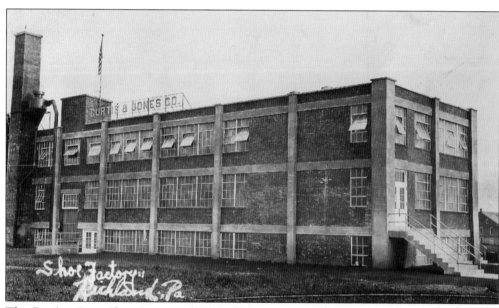

The Curtis & Jones Shoe Company built its factory in 1917, with an addition in 1920. The firm had started on the third floor of the Richland House on Main Street. In the 1970s, the factory moved to Womelsdorf in Berks County. By the early 1990s, the Richland Manufacturing Company, making electrical wire harnesses for heavy-duty trucks, was located here. As of 2012, the name of the firm here is Fargo Assembly of PA, Inc. (Courtesy of Nancy Gambler.)

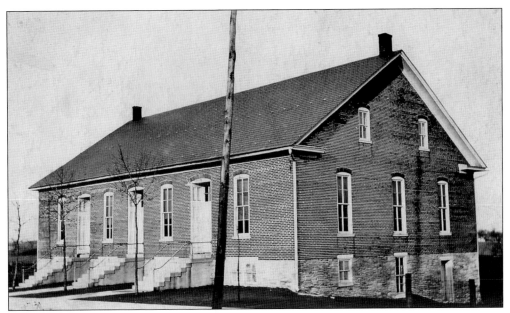

Richland's Church of the Brethren was built in 1912. The origin of the congregation dates to nearly a century earlier, when Abraham Zug's family migrated to the Richland District from Montgomery County, Pennsylvania.

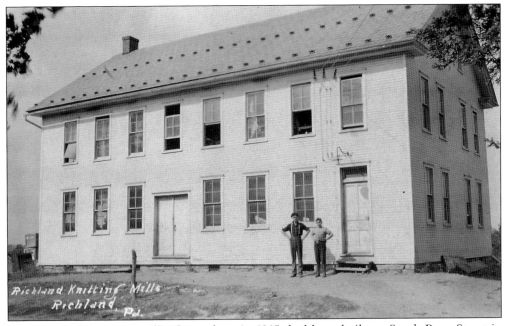

The Richland Knitting Mills, shown here in 1915, had been built on South Race Street in 1902. Originally called the A.C. Haak Hosiery Mills, this structure was completely destroyed by fire in February 1919, with a loss of 200 knitting machines and 60,000 dozen hosiery. (Courtesy of Jack L. Kiscadden Jr.)

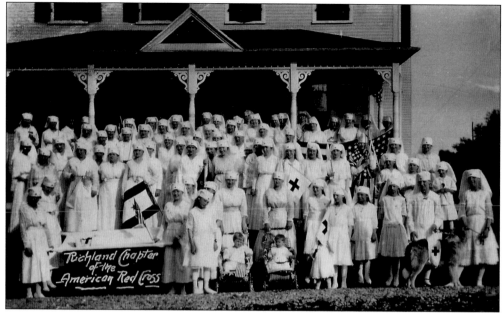

The Richland chapter of the American Red Cross posed for this photograph in 1918 in front of 104 South Park Street beside the Patriotic Order, Sons of America hall. The format of the card stock on which this postcard was developed was not available from the Kodak Co. until late in that year. Were not these ladies placing themselves in danger from the Spanish influenza epidemic raging at that time?

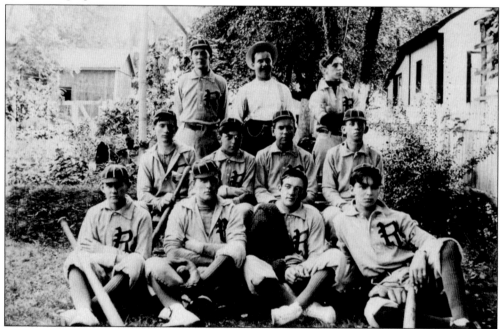

Seen here is the 1910 version of the Richland Chicks town baseball team. From left to right are (first row) two Leibig men, Horace Moyer, and Clair Leitner; (second row) Rob Leitner, Howard Leitner, Charlie Klopp, and George Smaltz; (third row) Paul Wike, Bill Klopp, and Harry Zeller. (Courtesy of Jack L. Kiscadden Jr.)

Eight

HEIDELBERG TOWNSHIP

KLEINFELTERSVILLE AND
SCHAEFFERSTOWN

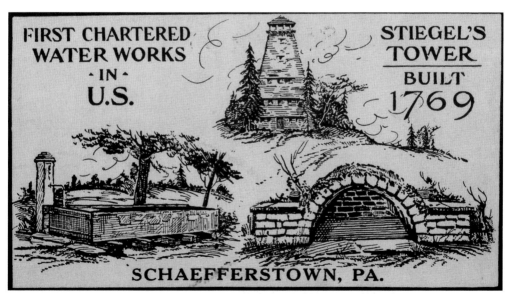

Schaefferstown is a community containing many 18th-century log structures. Its association with the life of "Baron" Henry William Stiegel, colonial glassmaker and ironmaster, and of the tower he built in 1769, are legendary. However, the town is most proud of having had an early chartered water system. The Fountain Company has the distinction of being the oldest gravitational water conveyance system, via underground pipes, ever established in a British colony in North America.

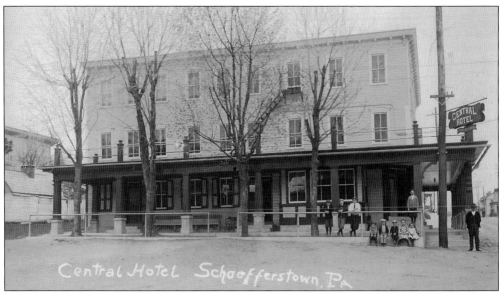

The Central Hotel stood on the northeast quadrant of the square in Schaefferstown until it was demolished in 1976. It was referred to as Fetter's Hotel, after its owner, John Fetter. This postcard features him (standing on right) and some Fetter family members. In the early 1920s, sons John S. and Charles Fetter, along with John Hollinger, left Schaefferstown for Atlantic City, New Jersey, where they operated three hotels—the Boscobel, Jefferson, and Monticello—on Kentucky Avenue that became popular with Lebanon Countians on vacation. (Courtesy of Michael A. Trump.)

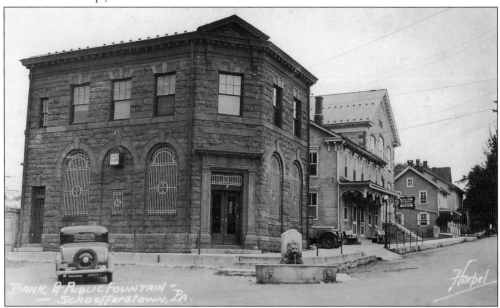

The First National Bank of Schaefferstown was built in 1910 on the northwest quadrant of the square. This mid-1930s view shows Sam Fetter's Restaurant to the right and, beyond it, the taller Patriotic Order, Sons of America Hall, built by 1911. Since the 1970s, the latter has become the Thomas R. Brendle Library and Museum of Historic Schaefferstown, Inc. The restaurant is now a parking lot. (Courtesy of Michael A. Trump.)

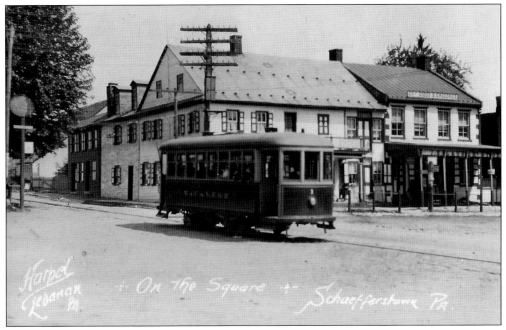

This 1914 postcard shows the southeast corner of Market Square, Schaefferstown. One of the original battery-powered cars of the Ephrata & Lebanon Street Railway Company is crossing the square. Note the absence of a trolley pole. Due to the South Mountain between Ephrata and Kleinfeltersville, battery cars proved unsuccessful. An apartment building and, at right, Lauser's Store, are seen behind the car.

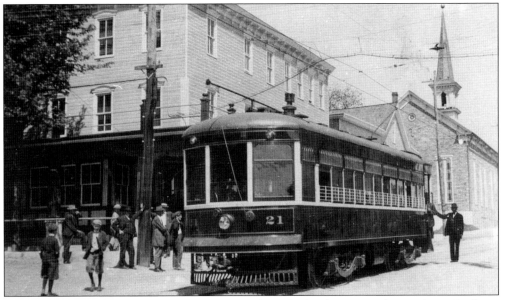

This December 1915 view shows the recently electrified Ephrata & Lebanon Street Railway Company's Cincinnati Steel Car No. 21 at its stop by the Central Hotel on the square in Schaefferstown. The first trolley run to Ephrata from Lebanon had been made in May of that year with Moses Fetter as conductor (standing, right). The Central Hotel was razed in 1976, and a parking lot for St. Luke Lutheran Church occupies that space today.

95

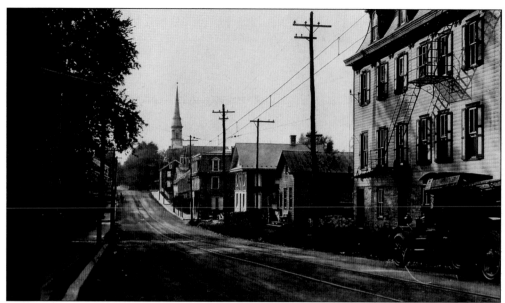

This view looks west on Main Street from Market Square on a day in 1919. A truck is parked alongside the Franklin House, and in the distance is the spire of St. Paul's Reformed Church (now United Church of Christ). The small building west of the Franklin House was a cigar factory, later the post office, and, today, the site of a Fulton Bank branch. Irwin Horst's Cigar Factory stood two doors beyond that. The site was most recently an apartment house.

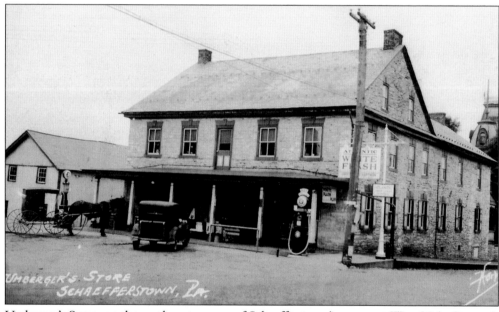

Umberger's Store, on the southwest corner of Schaefferstown's square at West Main Street, is seen in this 1933 postcard with a Packard automobile, Atlantic White Flash gasoline pumps, and John Brunner's horse and buggy. Around 1800, this limestone structure had replaced an earlier log store, which had been built by Abraham Rex Sr. The store was operated by two generations of William Weigleys after 1839, until the Umberger family became proprietors from 1903 until January 1990. Today, this building is occupied by Antiques-on-the-Square.

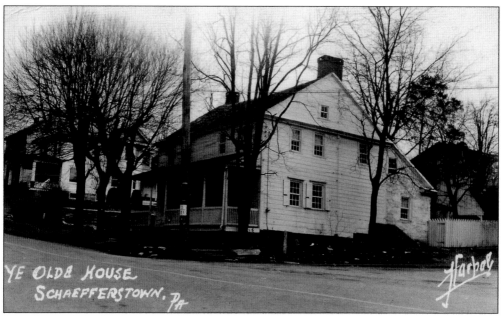

The phrase "Ye Olde House" is a ridiculous label for one of the most important Colonial-era structures in the Middle Atlantic states. This is the Gemberling-Rex House, half-timbered with original hand-painted wall designs. This was both a home and a tavern in the 18th century. For more information on this building, please see *A Country Storekeeper in Pennsylvania; Creating Economic Networks in Early America, 1790-1807* (2008), researched and written by Diane E. Wenger, archivist of Historic Schaefferstown, Inc. (Courtesy of Jack L. Kiscadden Jr.)

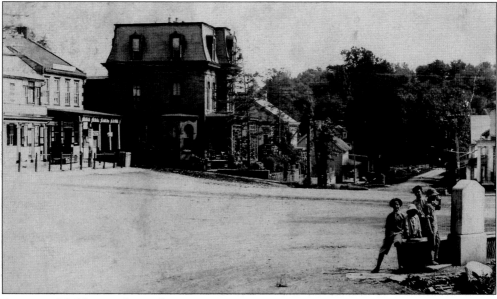

A group of children gather at the new Zimmerman Fountain in 1910. This view is to the south, across Schaeffertown's Market Square toward the Fountain Park. At left is Lauser's Store, and at center is the Zerbe Mansion, which was the home of physicians for several generations. Beyond it is the Lauser home, which since the late 1980s has been the home and gallery of primitive artist Barbara Strawser.

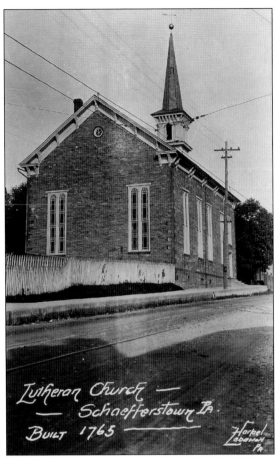

Lutheran Church —
— Schaefferstown PA.
Built 1765 —

Harpel
Lebanon
PA

St. Luke Lutheran Church on East Main Street is believed to have been organized in 1730. This structure was built in 1765. The pastor from 1770 to 1773 was Rev. Frederick Augustus Muhlenberg, who in 1789 became the first Speaker of the US House of Representatives and stood to the left side of George Washington at his first inauguration. Henry William "Baron" Stiegel, colonial iron and glass manufacturer, occasionally attended church here.

Standing near the Weigley family memorial on a day during World War I, two men are planning an expansion of the Schaefferstown Cemetery to the east. Several generations of Weigleys have been buried here since the early 1880s, although not the William Weigleys, who built the mansion on Main Street. The descendants of Rex Weigley (1852–1898) lie buried here.

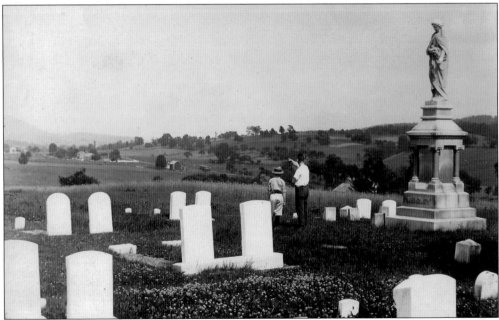

Erected in 1858 as the German Reformed Church, today this is St. Paul's United Church of Christ. This stately brick church is the third edifice of the congregation. The first one was a Union Church, built of logs and shared with the Lutherans until 1765. The second building was located where the boys are shown playing "nipper." One wonders whether the recipient of this postcard in July 1906 heeded the advice given.

These seven ladies and a boy are having great fun eating cherries and spitting out the pits in this photograph from around 1912 or 1913. Charles Huber's bicentennial history of Schaefferstown (1963) mentions that the tradition of a Cherry Fair started during the first half of the 19th century and was held on the northern half of the square each June. More recently, the Cherry Fairs have been held on the Alexander Schaeffer farm south of town. (Courtesy of Michael A. Trump.)

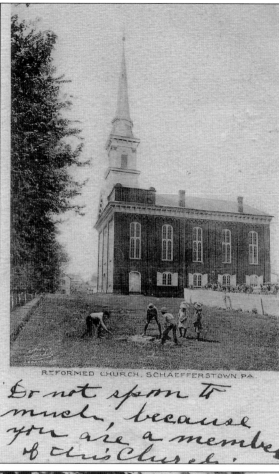

REFORMED CHURCH, SCHAEFFERSTOWN, PA.

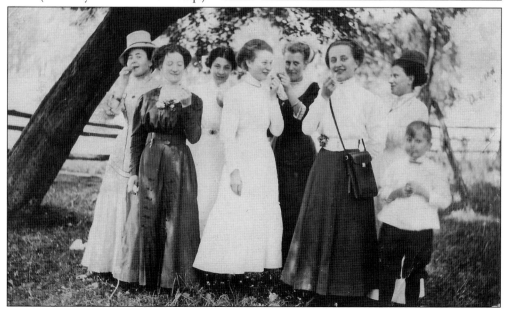

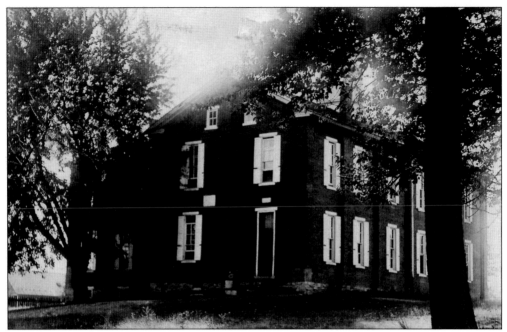

Schaefferstown's school, constructed of red brick, was built in 1883 and served as both the elementary and high school until the graystone high school was constructed in 1936–1937. The brick building remains standing behind St. Paul's United Church of Christ and serves as a social hall and Sunday school for the church. Look closely to see the wing added in 1904.

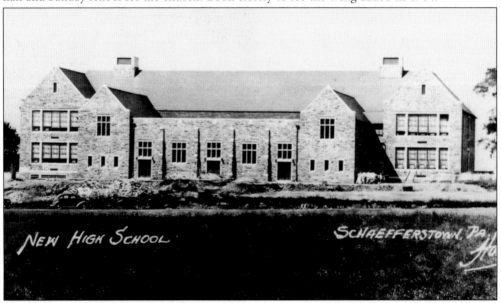

The graystone high school opened for instruction in September 1937. It was called Heidelberg Township Elementary and High School because all 12 grades for all township students were taught in this building until 1962, when the Eastern Lebanon County High and Middle Schools campus opened four miles north. This structure served as the Schaefferstown Elementary School until 2010, when it became Lebanon-Lancaster Intermediate Unit 13, offering special education instruction, and also Community School North.

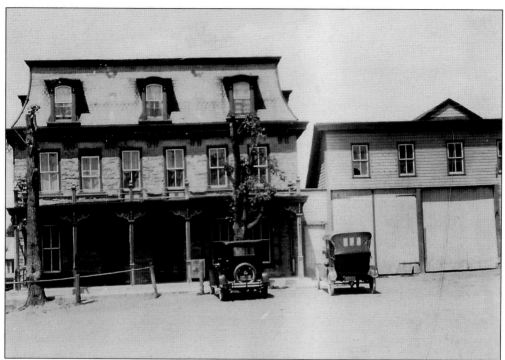

The Franklin House stands on the
northwest corner of Market Square. It
has been an inn and tavern since 1746,
when its name was The King George.
Pioneer roads between Philadelphia
and Middletown, and Lancaster and
Womelsdorf (Conrad Weiser's town)
crossed here. In 1884, the structure was
remodeled and enlarged, with the addition
of a third story and mansard roof. The
frame building on the right served as a
livery stable.

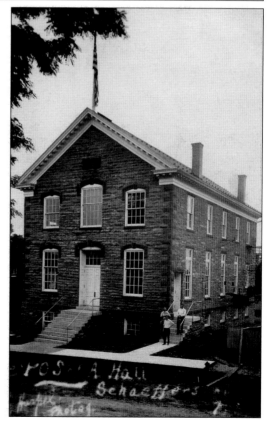

Built in 1909–1910 by the Patriotic Order,
Sons of America as a meeting hall, this
building also served as a community
center for 60 years. In the mid–1970s, this
hall became Historic Schaefferstown's
Brendle Library and Museum. Thomas
Royce Brendle (1889–1966) compiled an
important Pennsylvania German folklife
collection, which is preserved here. He had
spent much of his youth on the Alexander
Schaeffer farm, then at the home of
his grandfather.

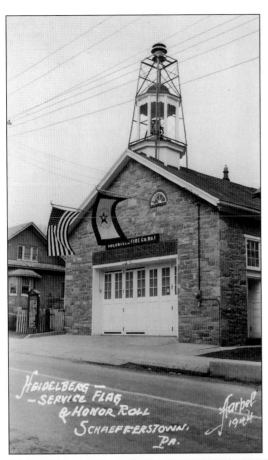

Schaefferstown's Volunteer Fire Co. No. 1 is shown here in 1944, with a World War II honor roll outside. Schaefferstown's present fire company was founded in 1909. This structure originally had been built in 1847 as an Evangelical Church (Moses Dissinger's). After a fire in 1919, the fire company purchased and restored it as its hall until they moved to a new building in 1972. Presently, it is a Scout troop hall.

Officers of the Schaefferstown Volunteer Fire Company pose outside the fire hall in 1920 with the company's first fire engine, the soda-acid hand pumper purchased in 1876. Shown here are, from left to right, Luther Plasterer, William Krieger, Irwin Miller, Tom Strickler, and Jonathan Corl. This engine is preserved inside the present firehouse, built in 1972, located on the northeast corner of Locust and Oak Streets.

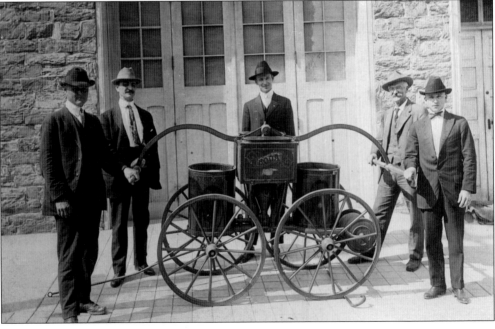

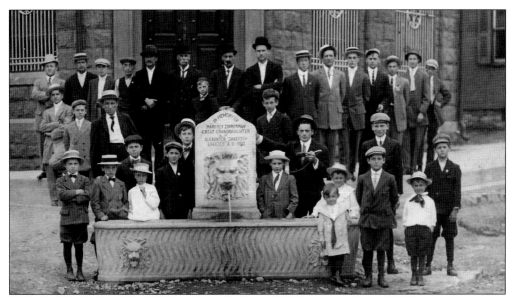

When Alexander Schaeffer laid out the town's water system, there were two wooden troughs on the square. The trough on the northwest corner was replaced in 1910 with this granite fountain by Matilda Zimmerman, in memory of her mother, Mary Rex Zimmerman. It seems that half of Schaefferstown's males got into this photograph in the early 1920s. Schaefferstown had one of the earliest—perhaps the first—municipal water systems in America.

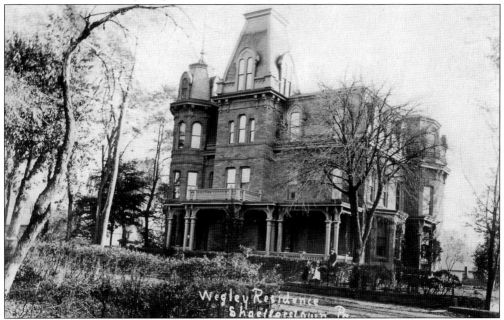

The William M. Weigley Mansion on Main Street, west of his store (Umberger's, after 1903), was built in 1883 from brownstone quarried southeast of Schaefferstown. Plans and drawings of the 22-room mansion appeared in *Godey's Ladies Book,* a popular Victorian magazine. Weigley was married to Anna Rex, great-granddaughter of Alexander Schaeffer, and was instrumental in establishing the Schaefferstown Academy and other educational and religious endeavors. Joe and Ruth Edwards are the current owners of this mansion.

Seen here is the home of the Dierwechter sisters—Esther, Grace, and Naomi—folk artists and daughters of John R. Dierwechter, who bought the house in the mid-1930s. Built in 1810, this house was carefully moved some distance to the west in 2011 because of construction on a new Route 501 highway bypass of Schaefferstown. The Dierwechters' barn and shop, open to the public every December, remain at the original location.

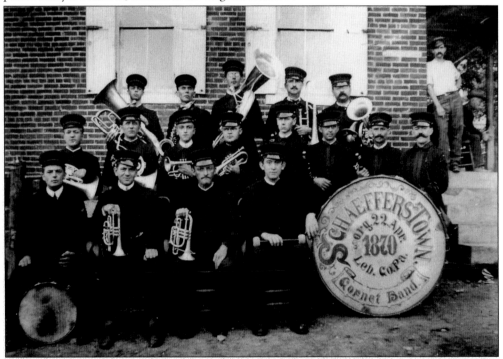

Members of Schaeffertown's Silver Cornet Band pose by the side of the Kleinfeltersville Hotel in 1911. Organized in 1870, this was one of at least 14 town bands around Lebanon County in the early 20th century, five of which were in the eastern part of the county. James Wike, the conductor, can be seen on the right in the second row, behind the drum.

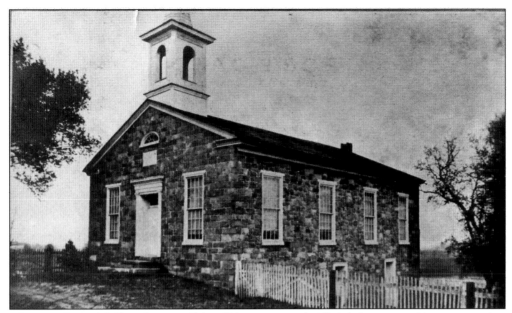

Albright Memorial Church was built in 1850 next to Jacob Albright's grave, and its congregation remained an active one for Pennsylvania German-speaking evangelicals until the late 1890s. Located on Albright Road, one-quarter mile north of Kleinfeltersville, this church is maintained as a memorial to Albright, founder of the Evangelical Association, who died nearby in 1808.

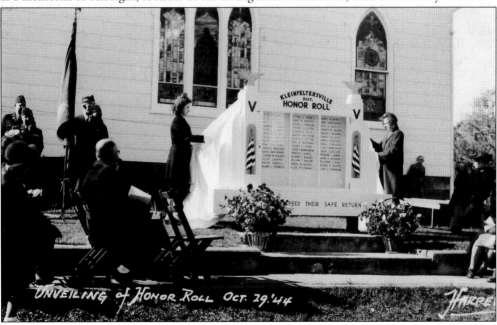

Americans in every community expressed patriotism through sacrifice during World War II. Honor roll boards listing those who served in the military, and those who gave their lives, were erected. Kleinfeltersville unveiled its honor roll with a parade and ceremony on October 29, 1944. Standing at left is Marie Bollinger Steinmetz and on the right is Marie Hoffman Hippert. Seated left of center is Rev. John G. Levengood, founder of the Alberta Memorial Tabernacle, southwest of Kleinfeltersville. (Courtesy of Cecilia Fetter Stephen.)

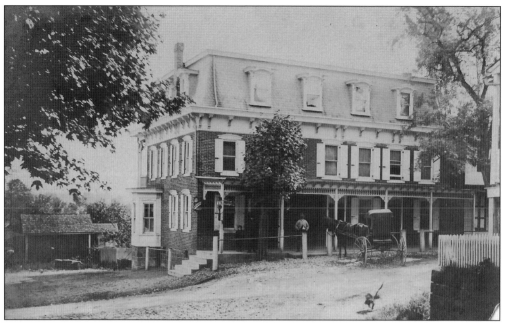

The Kleinfeltersville Hotel looked like this in 1906. An inn built by the 1860s was expanded by Henry Noll to two stories in 1884, with the mansard-roofed third story added by proprietor Adam Spade. Still operating in 2012, offering food, drink, and indoor games, this hotel remains popular. (Courtesy of Cecilia Fetter Stephen.)

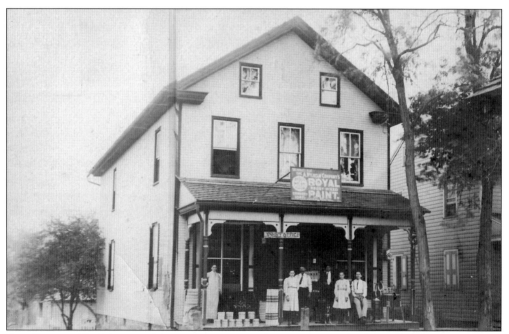

Standing outside Adam Weik's store in 1906 are the proprietor (third from left), his clerks, and probably some of his family. At that time, the building housed the post office. Weik had opened the store in 1898. By 1973, Doster's Food market was here, including gasoline pumps. During the intervening years, the store had been known as Levengood's.

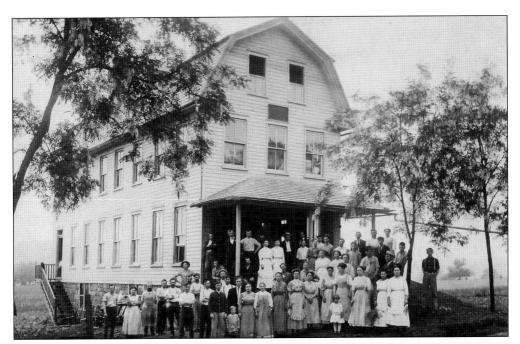

Witter's Cigar Factory workers and managers posed for this company photograph in 1912. At least 55 adults are pictured. Prior to 1909, this building stood on Schaefferstown's square, on the northwest corner, and was known as Carpenter's Hall. When the bank took over that site, the building was moved to Kleinfeltersville. Today, it is an apartment house.

The Alexander Schaeffer House is seen here in the late 1960s, shortly after Historic Schaefferstown, Inc., was established to preserve an 18th-century Pennsylvania German farmstead. The Schaeffer House is a two-and-a-half-story stone structure, possibly built as early as 1736, and enlarged around 1771 to its present bank house configuration. It follows the European tradition of combining domestic and manufacturing (whisky production) spheres in one building. In 2011, the Schaeffer House was designated a National Historic Landmark.

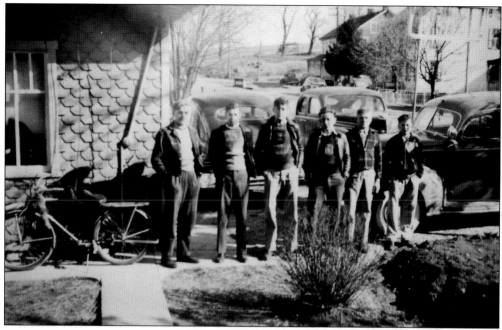

Keller Bros. Ford is a business with more than 50 employees as of 2012. It is located within a short distance of the original garage started in 1921 by Mark and Ammon Keller in Buffalo Springs. Seen here in the later 1930s are members of a younger generation who returned to the original garage for this picture. Brothers Mark Jr., Monroe, Norman, and Titus are believed to be in this view but cannot be identified precisely.

This postcard shows the 1931 building and the expanded Keller Bros. Ford sales and service, relocated a short distance east of the original garage in Buffalo Springs. This building is very recognizable today although it has been expanded to the right with modern facilities and offices as of 2012.

This is a mid-20th-century view of Buffalo Springs in Lebanon County, Pennsylvania. By this time, Keller Bros. Ford sales and service was synonymous with the village, as the signs in the foreground illustrate. The village was named Buffalo Springs due to local springs where several buffalo once drank (local lore but not documented).

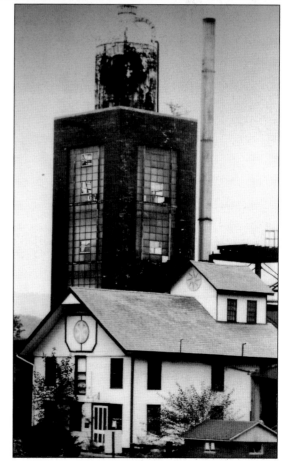

Michter's Distillery has claimed to be the oldest distillery in America, dating back to 1753. However, it has not been in operation since the late 1980s. During the bicentennial years of the 1970s, when the Yocum Brothers of Lebanon distilled sour mash (pot-still) whiskey here, they advertised it as "The Whiskey that Warmed the Revolution." Previous owners have been John Shank (1753), A.S. Bomberger, and a firm called Pennco. This photograph, taken in 1995, shows deterioration.

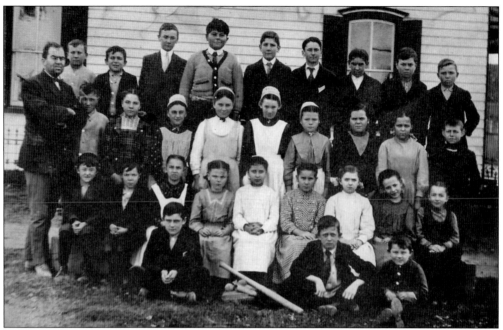

This 1907 photograph of Reistville's grammar school shows 30 pupils and a male teacher. Note that a number of the girls are wearing white prayer coverings. The area around Reistville was home to a number of Brethren families, with surnames such as Bucher, Kurtz, Royer, and Wenger. Two miles northeast in Jackson Township stands Lebanon County's pioneer Church of the Brethren—the Tulpehocken, or Royer's Meeting House, built in 1840.

Here is Ira Schlosser's garage with two gas pumps in Reistville on a winter day in 1948. Reistville is midway between Schaefferstown and Myerstown on PA Route 501.

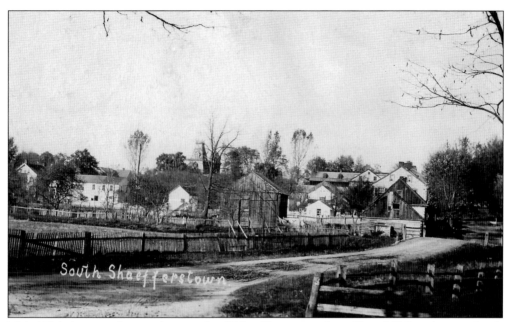

This 1906 photograph was taken south of Schaefferstown, where Sheephill Road meets South Market Street, and is facing in the direction of the town. Over the hill in the distance, the tower of the William Weigley mansion can be seen. South Schaefferstown also was known as "Canada" due to a man named Hull who lived here and who, during the War of 1812, followed General Hull's campaigns in Canada with a passion.

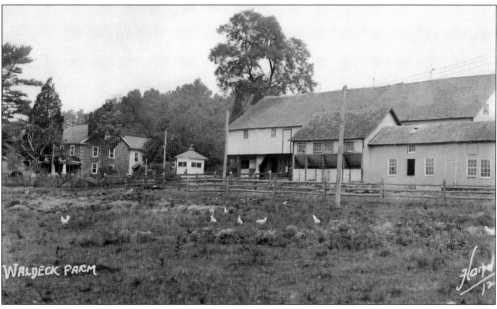

The John Gable family developed their farm, located three miles south of Schaefferstown, as the Waldeck Farms, which catered to tourists during the early automobile age. Sunday dinners here became well known. During the 1930s, Mildred Jordan stayed here to research and write *One Red Rose Forever*, a historical novel based upon the life of Wilhelm Henry Stiegel ("Baron Stiegel").

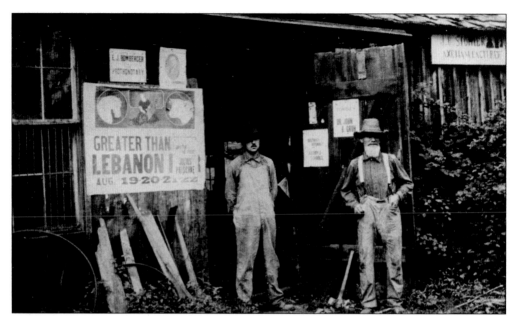

John B. Stohler (right), a famous axe maker, stands outside his blacksmith shop in the village of Johnstown, two miles southwest of Schaefferstown, about 1914. Neighbor Harry Sechrist stands in the doorway. The axes produced here were nationally known—stamped by hand and valued because of their durability. Stohler made axes here until his death in 1920. As of 1992, axes continue to be made by a descendant but are produced from a mold, not hand-stamped.

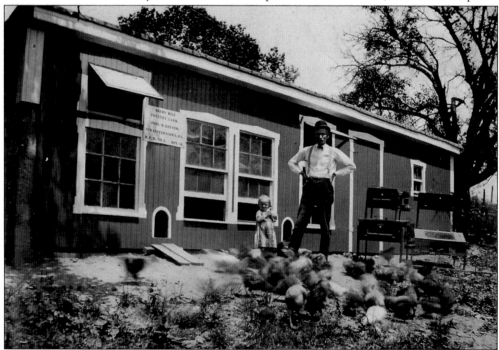

Raising poultry has been a major occupation and source of income for many families in eastern Lebanon County for more than a century. Joel M. Keller and his daughter pose at his Sandy Hill Poultry Farm in Heidelberg Township around 1915.

Nine

MILLCREEK TOWNSHIP
NEWMANSTOWN AND MILLBACH

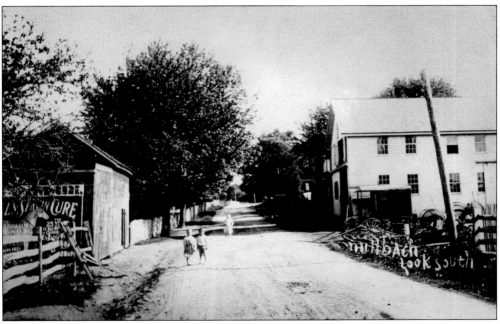

Millbach's main road in 1910 was not yet paved. Millbach remains a tiny village, but over the past two centuries it has had a hotel, general store, several shops serving the needs of local farmers and their families, and a stone mill built in the 1770s. The Germanic architecture of the House of the Miller and the stately old Reformed Church nearby reinforce Millbach's 18th-century ambiance. (Courtesy of Jack L. Kiscadden Jr.)

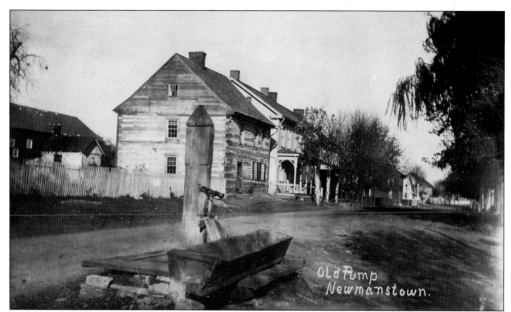

This is one of a number of Newmanstown photographic postcards produced by J.A. Heffelfinger of Womelsdorf, Pennsylvania. It shows Newmanstown's water pump about 1908. This view is to the east. The log structure seen behind the pump was the home of the Oscar Witter family at that time; today, it is the home of Carroll and Linda Lape on East Main Street. (Courtesy of Jack L. Kiscadden Jr.)

These buildings still stand on the north side of East Main Street in Newmanstown. The structure with two peaks housed the post office when this postcard was produced in the early 1920s. It was built by John H. Witter, the cigar maker, whose tobacco crates can be seen in front of his factory at the left. The house at center was that of Eli Wallace, of the well-known Wallace Plow Works. This view is to the east. (Courtesy of Jack L. Kiscadden Jr.)

This postcard of the Rising Sun Hotel, on the northwest corner of Main Street and Sheridan Road in Newmanstown, shows, at left, the horse-drawn stage that operated between towns, businesses, and industries in the Millcreek area. Mail also was delivered by stage at this time (1906), because Newmanstown was on neither streetcar nor direct rail lines. Today, the Rising Sun goes by the name of the Steppin' Out Inn.

In the 1920s, when this photograph of West Main Street was taken, Newmanstown's buildings mostly were located along one street and extended about one mile. Salem United Evangelical Church (the Church of Christian Outreach today) can be seen in this east-facing view. In recent years, there has been a huge growth in homes adjacent to the town toward the South Mountain in a community called Newburg Village.

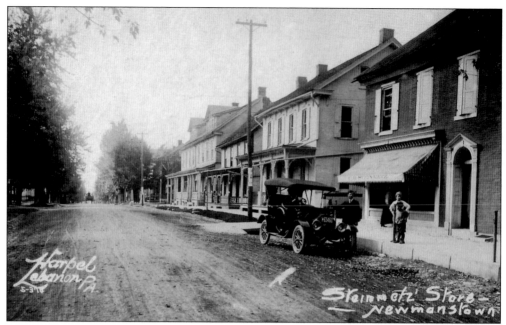

The C.H. Steinmetz General Store, on the north side of East Main Street in Newmanstown, is seen here in the early 1920s. Len's Friendly Market has been located on this site for the past several decades. One member of the Steinmetz family, perhaps Charles or Oscar, is in the driver's seat, and the other is standing next to the automobile. (Courtesy of Nancy Gambler.)

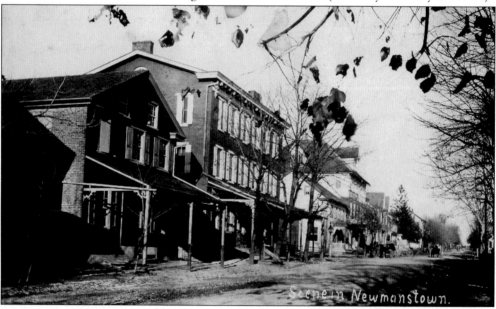

In 1906, photographer J.A. Heffelfinger stood on Newmanstown's unpaved Main Street to take this east-facing photograph. The building on the left has been remodeled and now operates as Millcreek Collectibles. A century ago, it was Walker Snyder's Restaurant, with a pool room above. The Newmanstown Co-Op store once was here. Next to this building is the Rising Sun Hotel. Across Sheridan Road was Josiah Stewart's house. The tall building beyond was the John H. Witter Cigar Factory. (Courtesy of Jack L. Kiscadden Jr.)

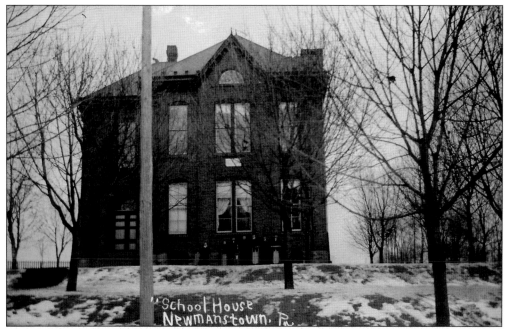

This is how the 1896 Newmanstown School appeared on a winter day in 1910. By the 1920s, it had been enlarged. All 12 grades were taught here for many years. In 1962, when the school districts in the five municipalities of eastern Lebanon County merged, this structure continued as an elementary school until 1969, then became Millcreek Township's hall. It was demolished in the early 1990s.

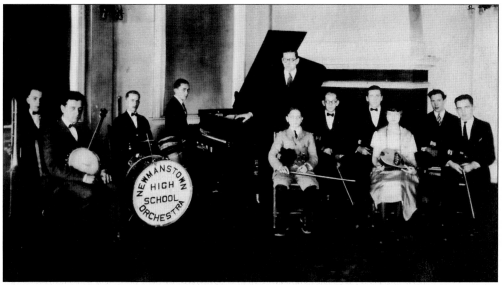

Newmanstown has nurtured a number of musicians who played in local bands and in the high school orchestra, which is pictured here during the 1922–1923 season. From left to right are Mark Burkholder (trombone), Russell North (banjo), William Stamm (drummer), LeRoy Keller (piano), Reuben Longenecker (orchestra director and superintendent of the high school), Donald Witter (violin), Clinton Hartman (violin), Elmer Wengert (violin), Ethel Hickernell (mandolin), Harry Kennedy (violin), and Guy Zimmerman (violin). (Courtesy of Jack L. Kiscadden Jr.)

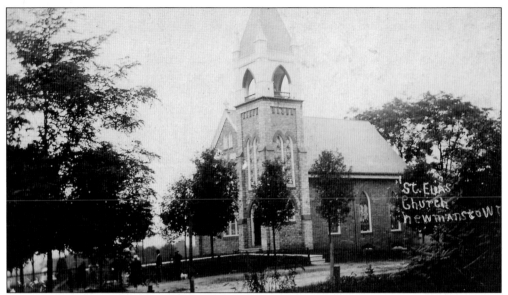

St. Elias Church was built in 1850 to serve as a union church for the Lutheran and Reformed faiths. Today, only the latter worship here, at what is now called Elias United Church of Christ. Remodeled in 1905, the church contains a beautiful stained-glass window and stands majestically on a hill along the Sheridan Road. Newmanstown's Trix sisters, popular entertainers of the 1920s, lie buried in the adjoining cemetery on their Yeiser family plot.

Here are Newmanstown's well-known Trix sisters, Helen (left) and Josephine. Trix was their vaudeville stage name by the 1920s. Better known in Europe than in the United States, Helen (1886–1951) and Josephine (1898–1992) were daughters of J. Henry and Catharine Yeiser. Helen composed musical reviews that the sisters presented: "The League of Notions" and "A to Z." In London, they performed for the royal family, and in Paris, they operated a cabaret. (Courtesy of Carroll D. Lape.)

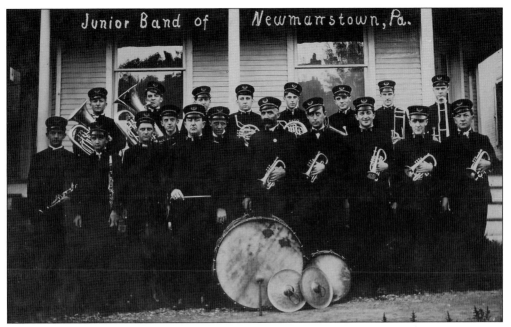

The Junior Band of Newmanstown poses at a house on Main Street in 1912. The director was John Noll. Identified members in this picture are bass drummer Sam Schoener (behind drum) and, at far right in the second row, the trombone-playing Burkholder brothers. Postcards also exist of the "town band of Newmanstown," a larger group, posed before this house. Sheridan, a mile away to the north, also had a town band, with Harvey Noll as its director.

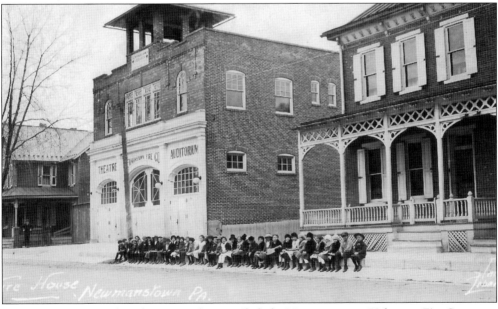

By September 1919, when this postcard was mailed, the Newmanstown Volunteer Fire Company had constructed a hall that included a theater and an auditorium. Where the house at right once stood, a wing has been built for social gatherings. Movies again are being shown in the theater. In 1947, a new firehouse was built to the rear, facing Sheridan Road. Along the curb are seen the younger generation of 1919. (Courtesy of Jack L. Kiscadden Jr.)

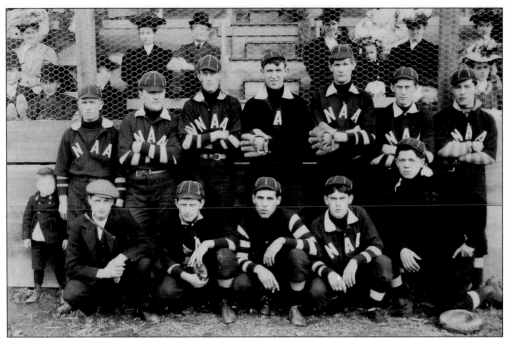

With spectators waiting in the stands for the game to start, the Newmanstown Athletic Association's baseball team of 1906 posed for this picture. Shown here are, from left to right, the following: (first row) "Luttie" Weiss, Johnny Harper, Robert Miller, George Wartluft, and Charles Gingrich; (second row) little Boger, Bob Boger, Hoyt Bender, Eddie Weik, Bill Schaeffer, Zack Moon, George Hippert, and George Miller. (Courtesy of Jack L. Kiscadden Jr.)

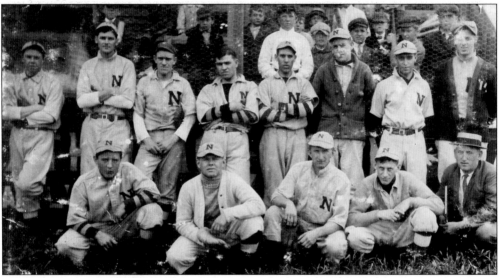

A Newmanstown baseball team poses before a game sometime after 1913 but before the United States entered World War I. Shown here are, from left to right: (first row) George Miller, Rufus Tice (hotel man), Harvey Strickler, George Hippert, and Dick Ibach; (second row) Speck Trexler, Sam Schoener, Piggy Anderson, Hal Anderson, Bob Miller, Joe Ritter, Warren Bennethum, and Ed Wise. The message side of this postcard tells that the boy in the white sweater (Levi Rutter) was killed (gassed) in World War I. (Courtesy of Jack L. Kiscadden Jr.)

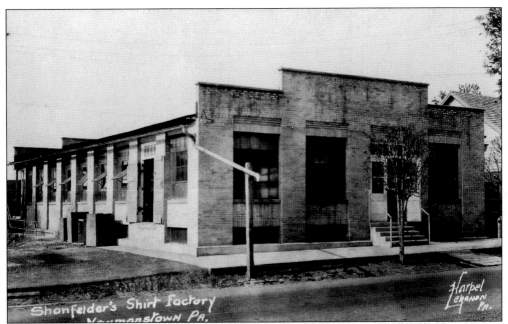

Shanfelder's Shirt Factory is seen here on a 1920s postcard produced by Luther Harpel, Lebanon County's best-known photographer. The factory was located on East Main Street and made white shirts. In recent years, this structure has been home to the Elco Branch of Lebanon County Christian Ministries. (Courtesy of Jack L. Kiscadden Jr.)

The railroad bypassed Newmanstown, but its citizens could walk east on Main Street a short distance to see the "Queen of the Valley" fly by each evening, or listen for its whistle by which to set their clocks. The closest Philadelphia & Reading Railroad stations were a few miles away, in Sheridan to the north and Womelsdorf to the east. (Courtesy of Jack L. Kiscadden Jr.)

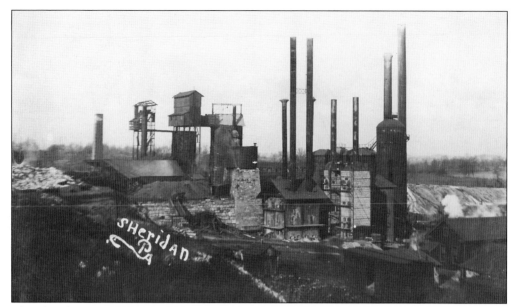

The Sheridan Furnaces are seen here as they appeared during World War I. The first Sheridan furnace was established in 1862 by William F. Kaufman and Frederick Hunter. A second furnace was built in 1874. Kaufman Interests of Reading, Pennsylvania, managed the industry. By 1950, the E.J. Lavino Company owned the furnaces and had become the world's leading producer of manganese iron. By 1970, the furnaces were shut down and being dismantled. (Courtesy of Nancy Gambler.)

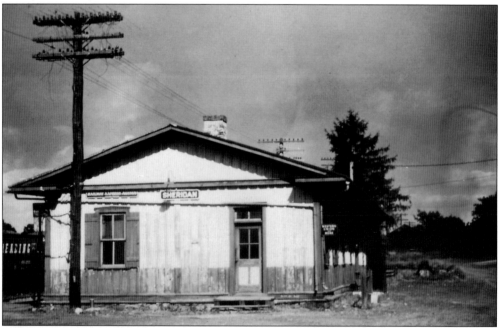

Shown here is the Philadelphia & Reading Railroad's Sheridan station, built when the train came through in 1857. The station was destroyed by a train wreck sometime before the 1960s and had to be demolished. The village of Sheridan remains, with a number of substantial homes and a large mill at the bottom of the hill along the road between Newmanstown and Richland.

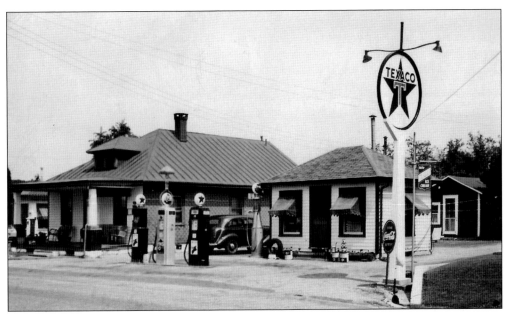

Seen here is Walker D. Snyder's Texaco station in the mid-1930s, when gas stations often were called "filling" stations. This station was one of two standing side-by-side on the south side of West Main Street. Pit Miller's station stands to the left in this photograph and, today, houses a motorcycle repair shop. This Texaco site is now a parking lot.

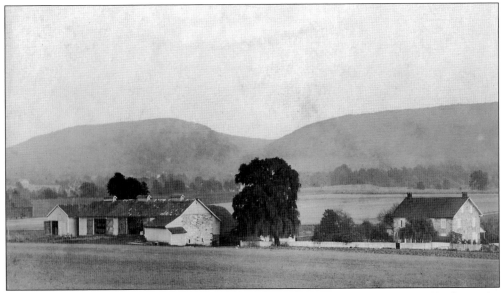

This south-facing view, from a farm west of Newmanstown along PA Route 419, shows the "kluft," or gap, in the South Mountain that takes one into Berks County. (Courtesy of Jack L. Kiscadden Jr.)

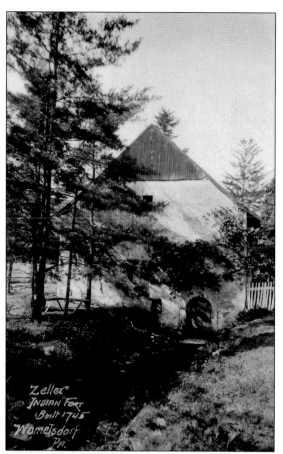

Here is Zeller's Fort, which is not at Womelsdorf as the postcard says; instead, it is a half-mile from Newmanstown. The Commonwealth of Pennsylvania's historical marker at the west end of Newmanstown tells visitors, "The State's oldest existing fort is half a mile to the north. Pioneers who came to the Tulpehocken from the Schoharie Valley built it in 1723, rebuilt it in 1745. It was used as a place of refuge during Indian wars." Schoharie Valley is in New York State.

The triple stone arches support the Philadelphia & Reading Railroad bridge at Sheridan, seen here in 1906. The Mill Creek flows through the left arch and a road through the right. Sheridan was first named Missimer's Station, after Henry Missimer, who built the first house and tavern in 1856. The railroad came through in 1857. After the Civil War, it was renamed in honor of Union general Phillip Sheridan.

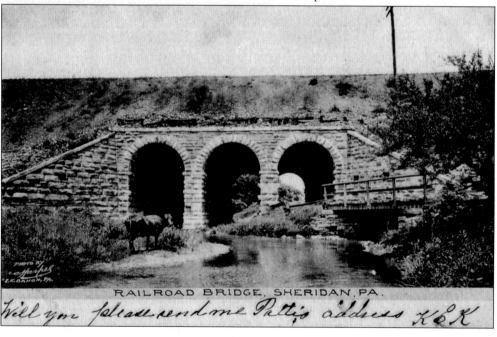

Built as a union church in 1790 by the Lutheran and Reformed faiths, who had shared previous log and frame structures on the site since 1747, this two-story limestone edifice contains three interior balconies. Unaltered in appearance since this 1912 view, St. Paul's United Church of Christ anchors the village of Millbach. It stands amid a pleasant grove, surveying cemetery and farmland, with the South Mountains in the distance. (Courtesy of Jack L. Kiscadden Jr.)

The heart of the village of Millbach is seen here on a 1912 postcard. The stone building on the left was the Millbach Hotel, which contained a store and also served as the post office. By the 1880s, Paul D. Schultz had become a merchant here, and also a collector of American Indian relics. From 1921 to 1971, William G. Reedy operated the store. Today, the Eisenhauer family lives where the hotel and store once were. (Courtesy of Jack L. Kiscadden Jr.)

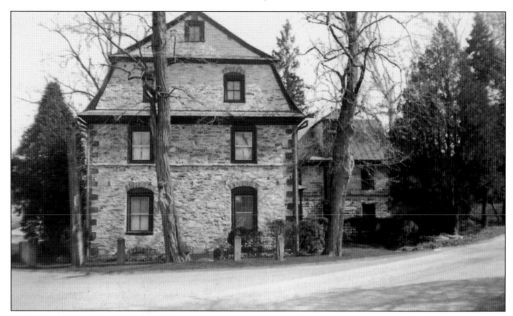

The House of the Miller, built by George Miller in 1752–1753, is one of the purest 18th-century, Germanic-style houses in America. Interior rooms from this house, exhibiting authentic Germanic features, were removed in 1927 to the Philadelphia Museum of Art. Situated along Millbach Road, this structure and its spring house across the road make a striking architectural statement. The present owner is Earle H. (Chip) Henderson.

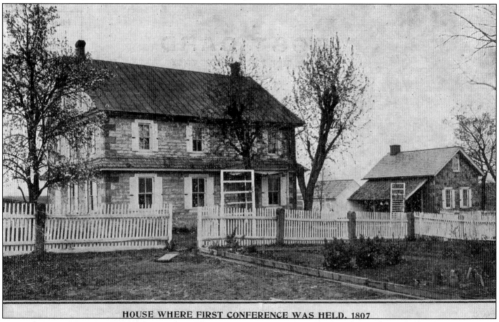

HOUSE WHERE FIRST CONFERENCE WAS HELD, 1807

This postcard features a house important to Methodist Church history. Constructed in 1770 of sandstone of reddish tint, this house served as the location in November 1807 for the first annual conference of the Evangelical Association, the denomination founded by Jacob Albright. He was elected its first bishop here. This was the home of Samuel Becker. Albright, who died in 1808, is buried several miles away, on the John George Becker farm.

These two gentlemen from Millcreek Township farms were photographed at Willow Grove Park in 1910. Lloyd Witter (left) eventually moved to Myerstown after a period of time living in Richland Borough and operated a cigar factory on West Carpenter Avenue. Joel Jacob Wiest remained on the family farm and prospered. (Courtesy of Joel Jonathan Wiest.)

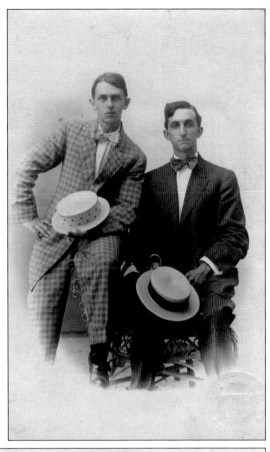

West Newmanstown was captured by photographer J.A. Heffelfinger of Womelsdorf on a late autumn day in 1906, before the road to Schaefferstown (Route 419) was paved. One can see Newmanstown's Elias Reformed Church in the distance. Prior to 1907, messages on postcards had to be written on the same side as the picture, as the other side had to be reserved entirely for the address. Postcards with divided backs for both messages and addresses were permitted as of March 1, 1907.

West Newmanstown.

This is near my earthly home. I remain your sister Sallie

DISCOVER THOUSANDS OF LOCAL HISTORY BOOKS
FEATURING MILLIONS OF VINTAGE IMAGES

Arcadia Publishing, the leading local history publisher in the United States, is committed to making history accessible and meaningful through publishing books that celebrate and preserve the heritage of America's people and places.

Find more books like this at
www.arcadiapublishing.com

Search for your hometown history, your old stomping grounds, and even your favorite sports team.

Consistent with our mission to preserve history on a local level, this book was printed in South Carolina on American-made paper and manufactured entirely in the United States. Products carrying the accredited Forest Stewardship Council (FSC) label are printed on 100 percent FSC-certified paper.

MADE IN THE
USA